The Museum Experience

Scott Douglass

Chattanooga State Technical Community College

THOMSON
TM
WADSWORTH

Australia Canada Mexico Singapore Spain United States

Printed in Canada
1 2 3 4 5 6 7 07 06 05 04 03

Printer: Webcom

0-534-63978-X

For more information about our products,
contact us at:
**Thomson Learning Academic Resource
Center
1-800-423-0563**

**For permission to use material from this
text,
contact us by:**
Phone: 1-800-730-2214
Fax: 1-800-731-2215
Web: http://www.thomsonrights.com

Wadsworth/Thomson Learning
10 Davis Drive
Belmont, CA 94002-3098
USA

Asia
Thomson Learning
5 Shenton Way #01-01
UIC Building
Singapore 068808

Australia/New Zealand
Thomson Learning
102 Dodds Street
Southbank, Victoria 3006
Australia

Canada
Nelson
1120 Birchmount Road
Toronto, Ontario M1K 5G4
Canada

Europe/Middle East/South Africa
Thomson Learning
High Holborn House
50/51 Bedford Row
London WC1R 4LR
United Kingdom

Latin America
Thomson Learning
Seneca, 53
Colonia Polanco
11560 Mexico D.F.
Mexico

Spain/Portugal
Paraninfo
Calle/Magallanes, 25
28015 Madrid, Spain

Acknowledgments

Although the author receives credit for the product of such an undertaking, this project would not have been fruitful without the support of many persons, to whom I owe a large measure of gratitude.

- The folks at Wadsworth / Thomson Learning: John Swanson for selecting me to complete the project; Rebecca Green for excellent editorial suggestions.

- My colleagues at Chattanooga State Technical Community College: Donald Andrews, Tisa Houck, Joe Helseth, Ken Page, Giselle Palmer, Kathy Patty, Fay Ray, De'Lara Stevens, Sandra Williford, and Sandra Winton.

- Also at Chattanooga State Technical Community College: student-writer David Padilla for persevering while working two jobs and avoiding summer's distractions.

- To Brian and Beth for allowing me more than my share of computer time.

- And, once again, that delicious root beer; thank heaven there's more where that came from.

CONTENTS

Chapter One
Visiting a Museum

As with so many opportunities of this nature, visiting a museum can be an exciting and rewarding experience—or it can prove disappointing and frustrating. Those who have enjoyed visiting a wide variety of museums eagerly anticipate the prospect of taking in yet another. But those who have not visited a museum might need a bit of persuasion to make that initial visit. This guide is intended to assist all who are considering a visit to a museum, regardless of your experiences.

Many readers will turn to this guide for specific assistance in writing a review of an exhibition or of a particular work of art. Because the guide offers a wide variety of insights intended to enrich anyone's visit to a museum, even those who have neither of these purposes in mind will likely benefit from reading these chapters.

Planning Your Visit

Your visit to the museum begins before you actually enter the building that houses the exhibits. In fact, it might begin a week or so in advance. A great way to prepare for your visit is to log on to the museum's website. A quick search with your favorite web browser will locate the URL for the museum's website. The information that you'll gather at the website will depend on the quality of the site's features and the time that you devote to investigating them.

The site's features will probably include the basic information that would help anyone planning a visit, particularly the museum's location and its hours of operation.

Many sites also include a calendar of events, usually on a monthly basis. For instance, like many museums, the Hunter Museum of American Art <www.huntermuseum.org/> in Chattanooga, Tennessee, offers "Freebie Friday" on the first Friday of each month, when no admission fee is charged. Such information might be especially helpful as you schedule your visit.

Other categories of information available on the website might include an overview of current exhibits as well as a virtual tour of the museum's collection. By becoming aware of exhibits currently featured at the museum you intend to visit, you'll know if you should schedule your visit so you can take advantage of the once-in-a-lifetime opportunity to view the Renoir exhibit that will be in town for a limited time. Similarly, by investing an hour or so to take the virtual tour, you'll gain valuable insights to help you prepare for your "real-time" visit. You could identify specific portions that you find especially interesting and then plan to devote sufficient time to viewing them. In addition, if your visit to the museum will culminate in your writing a review, information on the website might help you identify the piece or pieces on which you'd like to focus your attention.

Even if you capitalize on the information provided by the museum's website, call the museum's office a day or two in advance of your visit. As you've probably realized from other situations, material posted to the website might be out of date when you view it. A well-timed phone call allows you to confirm the museum's hours of operation and ticket prices, plus you can inquire about extended hours or discount admission for which you might qualify.

A few hours of preparation, then, can be extremely beneficial for your museum visit. Many visitors find it especially helpful to make a "Top 10" list of the works of art that they want to be certain to view. When you arrive, ask the staff member at the information desk for specific locations. The museum's staff wants to make your visit an enjoyable and memorable experience. Keep this in mind throughout your visit as well.

Museum Etiquette

A museum's two chief responsibilities compel it to exist in a perpetual dilemma. The museum's collection must be protected, of course, but visitors must be permitted to view and enjoy it. If the collection is merely locked in a vault, it will be preserved, but it won't be enjoyed. Then we must wonder for what purpose is the collection being preserved?

Even before you enter the exhibit areas, you'll encounter several of the museum's security measures. Most museums require that backpacks, briefcases, packages, and any other handheld objects be subject to inspection. If you refuse to submit to an inspection, the security officer will probably deny you entry. Many of these items—particularly a backpack and even an umbrella—are not allowed inside, so you'll be wise to leave them at home or in your car. Some museums offer limited locker rentals, but don't count on it.

You'll often encounter other security restrictions as well. While many museums offer areas for dining—from light snacks to extensive meals—food and beverage will not be permitted into the exhibition areas. Cameras of any kind are usually prohibited; flash photography is rarely permitted. If you're accompanied by a younger sibling or friend, be prepared to confirm that you are an adult, willing to be responsible for your companion's behavior. If someone in your group is quite young, be prepared to find that strollers are not permitted in the museum or, more likely, in some areas. (A telephone call in advance will help you avoid an awkward situation as you enter the facilities.) And if your group is fairly large, each member might be asked to wear a visitor badge.

Because a museum is a home for rare and priceless works of art, guidelines must be established so that the museum can fulfill its two chief responsibilities—protecting its works of art and permitting visitors to view them. It seems fair, then, that you as a visitor have two chief responsibilities: Be cautious as you view the exhibits and be considerate of other visitors (those visiting on the day of your visit and those who will do so in the years to come).

3

CHAPTER ONE

Virtually every museum depends on its visitors' adherence to a general set of guidelines, whether or not the guidelines are posted on signs or prescribed in a brochure. Although some visitors might consider them a nuisance, the guidelines are intended to protect the collection, not to inconvenience the visitor. If the choice has to be made, though, the museum will prefer the safety of its artifacts to the comfort of its visitors. Here are some general guidelines that museums commonly assume their visitors to observe.

- **Avoid touching the works of art.**
 Stay at least an arm's length away from the displays. Even pointing at objects might raise unnecessary concerns among the museum's security personnel. You might benefit from folding your arms or putting your hands in your pockets.

- **Avoid walking behind the ropes.**
 The ropes are placed to establish an area of safety for the work of art. Your intrusion into that space might set off an alarm and you might share an uncomfortable moment with the museum's security personnel.

- **Avoid using a display case as support for writing or sketching.**
 Too much pressure with your pencil might scratch the glass. Even more pressure might break the glass. Instead, use one of the museum's brochures. Better yet, come equipped with a notebook or a clipboard.

- **Avoid leaning on a display to steady your camera.**
 As you concentrate on framing the shot and seek to steady your body for a perfect photograph, you might not realize that your shoulder has found support from a thousand-pound ancient Egyptian stone artifact. Again, avoid that uncomfortable moment with the security personnel.

Accompanying these policies to protect the works of art are guidelines designed to allow each visitor to have an enjoyable and enriching museum visit. Most of the guidelines are based on good manners. When you recall that many museum visitors read display labels, listen to an audiotape, and share ideas about the works of art, you'll understand how many of these guidelines evolved to help everyone concentrate and enjoy.

- **Speak in quiet tones.**
 Think of the museum's atmosphere as similar to that of a library. Feel free to comment about the art and share your opinions with companions. Be thoughtful of other visitors, though. Avoid speaking at a volume that inadvertently shares your opinions with those who are not in your party and who probably have no interest.

- **Walk calmly and respectfully.**
 Maintaining a moderate—even a slow—pace allows you time to examine the works of art. You also avoid distracting others who have come to view stationary art rather than inconsiderate visitors zipping by. Again, consider the library's atmosphere.

- **Wait for others to finish at an exhibit.**
 Many visitors pause near a work of art to reflect on its meaning and the artist's intentions. Be watchful for such a situation and respect their time and space. After they've moved on, you may then approach the display.

Capitalizing on Your Visit

During your visit, you may move freely throughout the galleries. You might be surprised, though, by how tiring a museum visit can be. Most people find that a visit of a few hours is sufficient. Depending on the museum's size, your advance

preparation for the visit will help you see more and tire less. An especially useful way to prepare in advance is to wear comfortable shoes. Another method of delaying the fatigue that almost certainly intrudes at some point during the visit is to take breaks throughout your visit. Many museums have your tired feet in mind when they place comfortable seating areas in the galleries. If you're fortunate, you might find a seat near a work of art that you consider especially appealing. With that extra amount of time to enjoy the work, your rest will be all the more refreshing. Another seat might seem far from the artwork until you realize that the building's architecture is itself a work of art worth your attention. And if these options aren't successful in reviving you, visit the museum's cafeteria for a snack.

When the museum hosts a special exhibition, however, the traffic pattern is controlled in anticipation of the large crowds that will attend. In fact, the museum will restrict the number of visitors at specific times, often selling a limited number of tickets. Being aware of these circumstances will help you avoid missing a wonderful opportunity.

One approach to visiting a museum is to walk through all of the galleries, pausing only at those works of art that appeal to you. If you realize that a single visit won't permit you to walk through all of the galleries, you can choose an alternative approach that involves concentrating on a few of the galleries that you find most appealing. Your preparation for the visit—through the website and the phone call—will pay dividends here.

Whatever approach you choose, one of the best ways to make your visit more enjoyable is by taking advantage of the aids that the museum offers.

Figure 1: Typical Display in a Museum

Featuring the work of art and the display card (which has been enlarged)

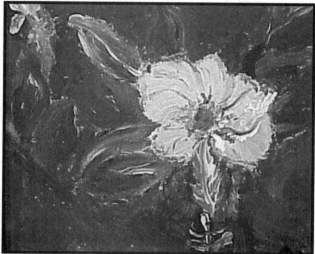

Brian Douglass
United States
1985 –
The First Burst of Spring
1994
acrylic on canvas
8 inches X 10 inches
acquired through anonymous gift

Brian Douglass

United States

1985 –

The First Burst of Spring

1994

acrylic on canvas

8 inches X 10 inches

acquired through anonymous gift

CHAPTER ONE

Written Materials

To help you enjoy your visit, many museums offer a variety of written materials. Among the most useful is a museum floor plan, which serves as a map to help you locate exhibits. An entire floor, for example, might be devoted to a historical period (Pre-Columbian), a geographical region (New England), or a style of art (Impressionism). As you tour the museum, look near each work of art for a small plaque that provides essential information related to the work.

Depending on the occasion, some museums provide other printed materials as well. An exhibit of a single artist's work, for example, might prompt the museum to provide a single-page pamphlet that describes the artist's technique and offers biographical information about the artist. An exhibit of the work of multiple artists might call for a more complex brochure, with perhaps a page devoted to each artist, her biography and technique. And then for an exhibition of the work of a celebrated artist (Mary Cassatt, for example), the museum will offer an elaborate catalogue for purchase. These are truly fine souvenirs, providing biographical information, informative commentary, and reproductions of the exhibit's works.

Audiotapes

An exhibition of a celebrated artist's work might also be accompanied by an audiotape that provides informative commentary about the works and the artist's techniques. For a nominal fee, you may rent the tapes along with a player and headphones, and then return all of these items to a convenient location at the conclusion of your visit.

Docents

Many museum staffs include docents, who serve as tour guides and are outstanding resources eager and able to answer your questions. To become a docent, each person must undergo thorough training to learn about the museum's

collection and its special exhibits. Because of their excellent service—usually in a volunteer capacity—docents are respected and admired by everyone closely associated with the museum. Inquire at the information desk for details on how you might join a docent's tour. And even if you don't join a tour, you might listen in on the docent's comments when you encounter her tour as you visit independently.

Enjoy Your Visit

You'll know that your visit has been a success if you leave the museum with the satisfaction that you've seen several memorable works of art. You'll be even more fortunate if you consider some of these works so exceptional that they remain in your mind for weeks to come. With an appropriate measure of preparation, your museum visit can be a stimulating and enriching experience. Perhaps the most useful bit of advice is to ask questions. Learn, enjoy, and return with a friend.

CHAPTER ONE

Activities

The following activities are intended to help you become familiar with what you'll likely encounter on display when you visit a museum.

Activity 1.1: A Virtual Visit to a Museum

Take a virtual tour of the Montreal Museum of Art's collections by visiting its website <www.mbam.qc.ca/lundi/a-cyber-lundi.html>. Select one of the galleries, where you'll find several works of art available for a closer look. When you select one of the paintings within the gallery, you'll find accompanying information:

> Artist's name
>> nationality
>> year of birth and year of death
>
> Artwork's title
>> year of completion
>> technique (e.g., oil on canvas)
>> dimensions
>
> Museum's method of acquisition (often a bequest)

Activity 1.2: A Virtual Visit to a Museum

In some instances, museums provide further insights about works of art. The Montreal Museum of Art's virtual display for Giovanni Battista Tiepolo's *Apelles Painting the Portrait of Campaspe*, for example, supplements the customary information with an explanation of the artist's intentions. Visit the web page for Tiepolo's piece <www.mbam.qc.ca/lundi/a-lundi8103.html> to learn more about the artist, his subject, and the connection to Alexander the Great.

Chapter Two
Selecting a Piece to Review

During your museum visit, allow enough time to look at each work, some more closely than others. For those of particular interest to you, gain further insights by reading the accompanying text on the display card or in the brochure. Be certain to note the location so you can return later for further scrutiny. After you've completed this initial "walk through" of the museum, return to several of the works that made significant impressions on you.

Perhaps you have a special fondness for a particular model of automobile. Have you paused to consider why it interests you? Is its color a key factor? Or is it the body style in general—regardless of color—that appeals to you? In a similar way, studying a particular piece of art in more depth can help you become more aware of your response to the piece. In fact, a closer examination of the work can be an extremely rewarding experience. It can lead to a more solid understanding of a work or an artist, sharpen your analytical eye, and increase your appreciation for art in general.

Do you occasionally see one of your favorite automobiles parked at Wal-Mart and catch yourself imagining that you're its owner? Now and in the future, you might also encounter an especially intriguing piece of art that compels you to pause, reflect, and even purchase it so you can place it in your home and admire it for many years to come.

Chapter Three provides information that will help you increase your enjoyment in a work—even if you're not writing a review. With an awareness of the

elements and principles discussed in Chapter Three, you'll have more thorough appreciation of what an artist is trying to convey.

Recalling the Assignment

Your Art Appreciation or Art History instructor may ask you to write a review of a museum exhibit or of a single work of art that you find especially interesting during your museum visit. If such is the case, be sure to recall the assignment specifics on your trip.

As you prepare to write the review, of course, you'll need to select a piece (or pieces) that lend themselves to your complying with the assignment's specific details. To accomplish this, you'll need to have a written copy of the assignment with you as you move through the museum. Don't trust to your memory. A minor oversight undetected until you've left the museum might necessitate a return visit. While that might not seem a severe penalty, the time devoted to correcting the oversight might delay your completing the assignment and risk late submission. Go to the museum fully prepared.

The information you'll need also depends on the assignment's specific requirements. Almost certainly, though, you'll need the title, the artist, the date of completion, the work's dimensions, and the medium. In addition, you should record any other information that you find on the display card and have the slightest suspicion that it might prove helpful as you write the review.

Figure 2.1: Typical Display in a Museum

Featuring the work of art and the display card (which has been enlarged).

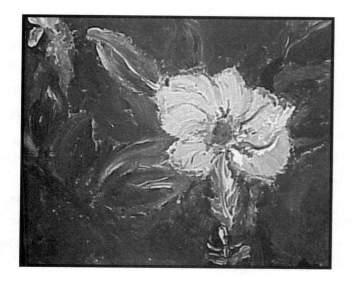

Brian Douglass
United States
1985 –
The First Burst of Spring
1994
acrylic on canvas
8 inches X 10 inches
acquired through anonymous gift

Brian Douglass

United States

1985 –

The First Burst of Spring

1994

acrylic on canvas

8 inches X 10 inches

acquired through anonymous gift

CHAPTER TWO

Recalling the Museum's Website

From your time on the museum's website before your visit in the museum you might recall the extent of the website's contents for selected works. Unless you can return to the website during your museum visit, however, you should avoid trusting your memory about specific details found on the website. If you're fairly confident that the work of art you select is featured on the website, then you can return to the website following your museum visit to confirm what you record in your notes. If you have any doubt, though, record detailed notes and assume that the website will provide little assistance.

You might also obtain a copy of any printed material—pamphlet, brochure, or catalogue—because it will contain accurate information. Unfortunately, though, because a museum's holdings are often so extensive, the printed materials rarely feature every work of art. If the piece that you select is not among those examined in the printed materials that you gather, then you've lost the advantage these items can provide.

Above all, realize that there's no substitute for the detailed notes you record as you view the work of art and devote serious thought to it. If you have the necessary information recorded in your notes, then you'll be far more confident that you're prepared to write the review. Later, you can consult the website or the printed materials. And, if necessary, you can return to the museum.

Activities

Anticipating and addressing the unlimited possibilities available to the assignment for you review far exceeds the scope of this chapter. The following activities, however, are intended to help you prepare for a museum visit that will culminate in a written review. These activities provide options similar to those that are commonly involved in review assignments. Although the opportunity to visit a museum with some of the great masterpieces on display is not an everyday occurrence for most of us, you can devote time to these activities and then apply the experiences you gain to the works of art that you view during your museum visit.

Activity 2.1: Portrait of a Historical Figure

Take a virtual tour of the Louvre Museum in Paris to view Hyacinthe Rigaud's *Portrait of Louis XIV* <www.louvre.fr/anglais/collec/peint/inv7492/peint_f.htm>. Consider the purposes behind Rigaud's portrait, which has become the most recognizable representation of the Sun King. Identify and discuss any insights about the French royal household that this portrait conveys. What insights do you also gain about the reasons for the approaching French Revolution?

Activity 2.2: Portrait of a Not-So-Famous Figure

A portrait's appeal doesn't necessarily depend on the subject's status or fame. Nor does it require a formal setting. Visit the website for the National Portrait Gallery in Washington, DC, to view Mary Cassatt's *Child in a Straw Hat* <www.nga.gov/collection/gallery/ggcassattptg/ggcassattptg-61101.0.html>. Why has Cassatt chosen to depict the girl in an informal pose? Speculate about the situation leading up to this portrait. Does the child's expression provide insights about her opinion of having her portrait painted?

Activity 2.3: Capturing a Historical Event

In depicting the survivors of a shipwreck, Theodore Gericault captured a moving scene from a contemporary news event in *The Raft of the Medusa* <www.louvre.fr/anglais/collec/peint/inv0488/peint_f.htm>. Because we are separated from the event by almost two centuries, the information accompanying the display contributes to our perception of the artist's intentions. Discuss how the historical background increases your opinion of the work of art. Notice the painting's dimensions. Comment on the effect that such a large format conveys.

Activity 2.4: Symbolism in David's *Liberty Leading the People (July 28, 1830)*

Consider the symbolism depicted in Eugène Delacroix's *Liberty Leading the People (July 28, 1830)* <www.louvre.fr/anglais/collec/peint/rf0129/peint_f.htm>. Read the commentary provided at the site, and then create a list of five other patriotic and inspirational works of art with which you are familiar. Have you seen these works translated for 21st-century purposes? Discuss an example of such "re-purposing."

Activity 2.5: Identifying Characters

An encounter with a work of art that includes a large number of famous characters is greeted as a challenge by many museum visitors, who devote hours to identifying the figures present. Raphael anticipated this penchant by providing *School of Athens*, a fresco in the Vatican's Stanza della Segnatura. At the New Banner Institute website <www.newbanner.com/AboutPic/athena/raphael/nbi_ath4.html>, an enlightening "answer key" is available. Note especially the identity of the figure depicted front and center, at the bottom of the painting. Then undertake a search for Raphael, who included his own likeness. (Hint: He's far to the right side.) When you encounter such a work of art, accept the challenge and utilize the tools (pamphlet, brochure, or catalogue) provided by the museum. You'll realize that such enlightenment enriches the pleasure you'll find in the work.

Activity 2.6: Landscape

Can you feel the cold captured in John Henry Twachtman's *Winter Harmony* <www.nga.gov/collection/gallery/gg70/gg70-49975.0.html>? Before photography was commonplace, artists were the primary hope for preserving landscapes. Painting a pond surrounded by trees on a snow-covered bank requires a significant measure of talent. But imagine the extraordinary genius necessary to enshroud the entire scene in a fog. During your museum visit, look for landscapes that make you feel truly a part of the scene.

Activity 2.7: Use of Light and Darkness

Sharp contrasts involving light and darkness assist the artist in focusing the viewer's attention. One of the masters of this technique is Michelangelo Merisi, better known as Caravaggio and often called the "other" Michelangelo. In *The Calling of St. Matthew* <gallery.euroweb.hu/html/c/caravagg/04/23conta.html>, Caravaggio directs the viewer's attention to Matthew rather than to Jesus, who gestures to summon the startled tax collector. During your museum visit, look for works of art that use sharp contrasts in light and darkness to convey some measure of the artist's intentions.

Activity 2.8: Focal Point

Artists draw from a wide assortment of devices to entice their audiences to view their works. Diego Velázquez combined several techniques in *Las Meniñas* <gallery.euroweb.hu/html/v/velazque/1651-60/08menina.html>, intending those in his audience to consider themselves "present" in the painting. Through contrasting light and darkness, the viewer's attention is obviously directed to the Infanta Margarita, who is surrounded by her attendants. A glance beyond the princess's head and slightly to the left detects much more, though. A mirror's reflection reveals the Spanish King and Queen, who are also present in the scene but are standing beside the viewer. During your museum visit, notice other techniques that artists utilize to direct the audience's attention to the primary focal point.

Activity 2.9: Depth of Field

A first encounter with the works of Andrea Mantegna often overwhelms even the most casual art observer. When you view *The Lamentation over the Dead Christ* <gallery.euroweb.hu/html/m/mantegna/2/dead_chr.html>, you'll have an idea of this artist's skills. When you realize that this painting is on a flat canvas surface, you'll appreciate Mantegna's remarkable mastery of conveying depth of field. With the left mouse button, click on the image to enlarge it. Then notice that the feet seem literally to extend beyond the edge of the table and off the canvas. Note also the torn flesh surrounding the nail wounds. During your museum visit, look for other works of art that seem to include depth—the third dimension—with height and width.

Activity 2.10: When You Don't Know What to Say

Certainly, it's acceptable to dislike some of the works of art that you encounter. But between the categories of "like" and "dislike" stands another sort that perplexes us. Occasionally, we encounter works of art so puzzling that we have difficulty expressing our responses. Many of Hieronymus Bosch's works often create this situation. For a better understanding of the confusion that often arises, visit the *Bosch Universe* website <www.boschuniverse.org/> and follow links to two of his more intriguing works, *The Garden of Earthly Delights* and *The Last Judgment*. You'll likely encounter others during your museum visit. Don't avoid them, however. Give them a genuine chance to "speak" to you.

Chapter Three
Responding to Art

Recording the information mentioned in the previous chapter will prove helpful in providing the background details about the work of art that you've selected as the basis for your review. But rarely does a review assignment deal solely with the background details. To achieve the far more important aspects of the assignment, you must incorporate your response to the artwork.

When you determined which piece of art you'd use for the review, you likely did so because you experienced a strong reaction to it. Searching beyond the work's surface appearance is extremely important as you analyze the work and express your reaction to it. Avoid relying merely on a basic response that the work is "pretty." Your strong reaction might include a variety of sentiments, each reflecting an emotional reaction. For example, you might consider the work of art disturbing, upsetting, emotionally draining, or politically charged.

Recording the details of that reaction is extremely important to your writing the review. Don't depend on your memory. Don't delay until after you've left the museum to record your thoughts. Instead, write down as much as you can recall about your initial response to the piece. Record notes directly in the museum's brochure (if one is available) and connect your comments to specific aspects in the photographic reproduction of the piece.

If the brochure is not available, do your best to sketch the artwork. The sketch is intended to supplement your notes, so avoid becoming concerned with the quality of your sketch. Instead, concentrate on recording your thoughts and

responses to the piece. Because you need not share your sketch with anyone, you shouldn't be concerned about its quality. If you record details sufficient for you to recall your intentions, then the sketch is successful.

Recording your initial reaction and then examining the work more closely to make the sketch will help you write the review. Perhaps you've depended upon a similar method of memorizing a list of vocabulary words. Re-writing the list and then reading the words in your own handwriting can prove quite beneficial when you must later write the words on a quiz. Similarly, your comments and your sketch will work together to help you react more completely and generate a significant response on which you can base your review.

Suggestions for Sketching

If you don't consider yourself artistically talented, then you might begin by creating a thumbnail sketch that captures the artwork's basic design. The thumbnail sketch is intended to record an overall view rather than a detailed analysis. If this work of art truly appealed to you—it seemed to reach out and grab your attention when you first entered the exhibit area—then you were probably responding to the features that your thumbnail should capture.

For the inexperienced artist, this less complex method of capturing the whole instead of the details will result in a more useful sketch. You've probably applied this method to other works—of music and of literature. Consider Beethoven's Fifth Symphony. Few of us could hum the entire work, but all of us can hum "tah-tah-tah-tum"—the "part" that Beethoven clearly intended to relate to the "whole." Similarly, reciting all of Edgar Allan Poe's "The Raven" isn't a talent boasted by many. But most of us recognize the refrain "Nevermore."

The task might be more manageable if you divide your "canvas" into quadrants. Imagine the piece of paper on which you're recording your sketch to be the work of art that you've selected. Begin by drawing two crossing lines to establish equal quadrants. Next, *imagine* identical lines on the work of art. Now, instead of sketching the entire piece, you've divided the task into four separate sketches that

will merge to reproduce the original. These divisions might also help you realize the principles of balance, motion, and emphasis that the artist incorporates in her work.

Providing color and value in your sketch can be fairly simple to accomplish. If the museum permits, use colored pencils. Otherwise, label areas of your sketch to capture its elements and your responses to them. Recall that your primary goal is not to reproduce the work of art. Instead, your purpose is to record your reaction to various aspects that you detected in the artwork.

Capturing texture in your sketch might be far more challenging. Recording notes that relate to the piece's texture, therefore, become extremely important if it is an element that you intend to address in your review. For instance, the website's reproduction of the artwork will likely lose some of the texture's qualities. As a result, your notes become all the more important.

Using a Checklist

After you have your sketch, make sure that you have all of the information you'll need before you leave the museum. The checklist on the following page details the aspects of a work of art that you should examine. Each is a little clue that can help you fully understand a piece, come to a conclusion about it's meaning and effectiveness, and then write a good review or paper if your class requires one. You may want to take notes on these details during your visit.

Checklist: Notes to Take on Your Selected Artwork

The Basics

☐ Write down all of the information from the work's display card:

☐ artist's name	☐ work's title
☐ artist's nationality	☐ date the work was completed
☐ dates of artist's birth and death	☐ work's dimensions
☐ the museum's method of acquisition	☐ medium and technique
☐ any additional information you feel may be important	

☐ What is your initial reaction to the piece?

Describe how the artist uses the elements of art within this piece.

☐ Line	☐ Light and Value
☐ Space	☐ Shape, Volume, and Mass
☐ Color	☐ Time and Motion
☐ Texture	

Describe how the artist uses the principles of design within this piece.

☐ Emphasis / Focal Point	☐ Unity and Variety
☐ Balance	☐ Rhythm
☐ Scale and Proportion	

Context, Content, and Meaning

☐ From your prior research and what you've learned from your museum visit, what is the cultural and historical context of your selected piece? Can you categorize it with a stylistic period?

☐ What is the content? What is going on? Try to identify people, the setting or location, and familiar objects.

☐ Can you pinpoint any themes? Is there any symbolism at work?

☐ Record your thoughts and emotions toward the piece. What do you think the artist wants you to feel when viewing his or her work?

☐ Putting all of these clues together, what is the meaning of the artwork? What do you think the artist is trying to say or do? And do you think that he or she is successful?

Figure 3.1: Steps in Sketching

The following steps might help you record a recognizable sketch of the original work of art.

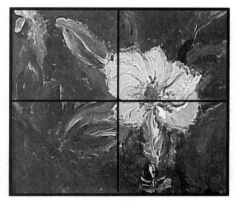

1) Draw two crossing lines on your "canvas" to establish quadrants.

2) *Imagine* identical lines on the work of art.

light green

orange

red

dark green

3) Make separate sketches of key features in the four areas.

4) Include notes to indicate colors.

CHAPTER THREE

Activities

The following activities are designed to encourage you to respond in multiple ways to a single work of art and to prepare you to record your thoughts as you prepare to write a review.

Activity 3.1

From the Appendix, select and connect to the website for a museum that you'd like to visit. Locate a work of art that appeals to you. Next, use a black-lead pencil to make a thumbnail sketch that captures the piece's basic design. Then record a minimum of five notes that address the work's color, value, and texture.

Activity 3.2

Using the same work of art as you selected for Activity 3.1, describe it using the following terms, as they are associated with art.
1. line
2. shape
3. value
4. color
5. space
6. texture
7. balance

Activity 3.3

Now describe the same work, using colloquial terms (e.g., "The bowl's octagonal shape is appealing," "This shade of green reminds me of the leaves on the weeping willow tree in my grandmother's backyard," or "The texture of the pitcher's handle seems unusual").

Activity 3.4

Again, using the same work of art as you selected for Activity 3.1, provide a psychological response based on your feelings and thoughts (e.g., "When I first saw the painting's row of buildings, I felt uncomfortable because I was reminded of my dentist's office").

Activity 3.5

Still with the same work of art as you selected for Activity 3.1, provide a judgment and explain your reasons for reaching this conclusion.

Chapter Four
Writing a Review

With the museum visit behind you, with appropriate notes recorded, and with an admirable sketch (if you do say so yourself) in hand, you've made significant progress toward being prepared to write the review. But a few steps remain before you're truly ready to write.

Purpose and Audience

Most students undertake the task of writing a review of a work of art because their instructor has made an assignment with specific requirements. Be certain that you have thorough understanding of your instructor's expectations. Your notes and sketch can't help if you don't have your instructor's specifications in mind as you embark on writing the review.

In many instances, though, other factors play a role in the point of view you adopt as you write the review. For example, you might assume that your audience is considering a visit to the museum. If this were the case, your review might be intended to convince your reader that a visit is certainly worthwhile, if merely to view the artwork on which your review focuses its attention. A second situation could involve your providing a review of a piece of art as representative of an exhibit that your audience is unable to attend. Your review, then, will provide insights that your audience will not have an opportunity to gain otherwise. Yet another possibility is that

your review might evaluate an entire exhibit that includes multiple pieces by a single or by multiple artists.

Your review will certainly depend on your expressing your opinion. But you should resist the temptation to think that your audience will accept your comments simply because they appear in print. For an art critic's opinion to find acceptance, the audience must be convinced that the comments are based on a reasonable and unbiased analysis supported by solid evidence that reflects a clear knowledge of terms and concepts associated with art.

Organization

The next step in writing the review is to arrange your notes so you can draw from them with ease as you move to the next steps in the process. Your notes should include—at the minimum—the following categories.

name of work	subject matter	unique qualities
name of artist(s)	artistic style used	social influences
media utilized	formal elements	historical allusions
theme		

If any of these items is not mentioned in your notes, you might return to the museum, rely on the museum's website, or consult an alternative website from among those mentioned in the Appendix. While you might not use all of this information, you won't suffer from having too much rather than too little.

Establishing a Thesis

With your notes arranged and fresh on your mind, you can develop a thesis that responds to the assignment's specific requirements. Don't expect the thesis to be a masterpiece at this point in the writing process, though. To get the writing process underway, however, you must have some sort of thesis as a guide. A

"working" thesis—one that gets your writing going, but isn't binding—will suffice. As you continue beyond the thesis and express your thoughts in writing, you might realize that a modified approach is preferable. You might even choose a completely different approach altogether.

The Review's Introduction

As with any piece of writing, your review's introduction plays an extremely important role in your review's overall success. Beyond the title (which we'll address soon), the introduction is the your first opportunity to capture the reader's attention and entice him to continue reading. If you lose your reader at this point, then the rest of your review—regardless of its beauty—is lost.

Determining the proper approach for your review can pose quite an obstacle. Most writers find success is writing *something* just to get the project underway. Perhaps your instructor has stipulated that your review begin with a summary of the basic information that identifies the work on which your review focuses. Consider the points that you could include: identify the museum as well as the work's title, subject, and artist; and then mention the technical details (e.g., medium and size). Even if these details are not required, presenting them in the opening paragraph will get the project rolling. You can return later to revise and modify, as you deem appropriate.

The introductory paragraph is the appropriate location for your "working" thesis. Remember that it is not binding at this point in the writing process. Placing the thesis as the introductory paragraph's concluding sentence will allow you to refer to it with ease as you write the rest of your review. During the final revision, you can place the thesis where you think it works best.

The Review's Body

The body paragraphs expand on the thesis. If your thesis lists the points of your argument, be certain that you address all of them and follow the order prescribed by the thesis. It's certainly acceptable for your thesis not to list the

elements explicitly; nonetheless, you must devise a logical and coherent order in which you present the elements. Also, remember to include each required element if you're writing the review to complete an assignment for class. A review that is otherwise brilliant might not receive a passing score if it does not fulfill the assignment's minimum requirements.

Within each body paragraph, recall the guidelines commonly associated with body paragraphs for virtually any essay. Provide a clearly stated topic sentence that presents the paragraph's subject. While the topic sentence can appear anywhere within the paragraph, it is often most successful when positioned as the paragraph's first sentence. In addition, compose each body paragraph with these characteristics: logical unity, adequate development, plausible organization, and sensible coherence.

The Review's Conclusion

Because the conclusion plays a major role in your review, be certain to capitalize on this final opportunity to persuade your reader to accept your views. Avoid merely restating the points you've already made in the review. If your final words lack the spark that your previous paragraphs have led your reader to expect, then the bored reader—even if he has accepted your opinions up to this point—might turn against you. Your reader expects more. And the energy that you've devoted to your review justifies better.

Instead, you might provide an enlightening conclusion by drawing an inference derived from the information that you've presented in the preceding paragraphs. This is not to suggest that you introduce a new concept, idea, or topic. Quite to the contrary, the conclusion is not the appropriate location for introducing new material. Clearly, a successful conclusion brings the review to a close. But it may do so while enriching it.

The Review's Title

With this first draft of the review completed, you're in a position to create a title. You might have devoted little attention to devising the title for a composition written in a college literature class. Because your instructor might be your only reader, you might view the essay's title as merely a necessary detail.

The title for your review, however, plays a major role in the review's success. Compare your review's title to the color of a car that you might purchase. If your first glance at a car reveals a color that doesn't appeal to you, then you'll probably give it little further attention, even though it might meet all of your other needs (price is right, low mileage, spotless interior, and great tires).

Certainly you want to attract the reader's attention, but the title plays an even more valuable role in the review's success if it reflects the spirit of the written work. You might draw from the artwork's title, from the artist's name, or from the style of art. But don't simply entitle your review "Manet's Impressionistic Style as Seen in *Le Déjeuner sur l'Herbe [Luncheon on the Grass]*." Boring? Yes. Intriguing? No. Longwinded? Yes. Informative? No. Instead, consider the brevity and appeal of "Join Manet for Lunch." The title's multi-faceted role urges you to devote significant attention.

The Finishing Touches

After you've written the entire review and topped it off with an especially clever title, don't overlook the final step in any worthwhile writing process. Because this step frequently pays great dividends, its value to your review's success is no less than the others'.

Proofread your review closely, looking for blatant errors, of course, but also for subtle problems that you might have overlooked earlier. Such problems involve much more than the computer software's spell-checker. The most frequently occurring problems that inexperienced writers encounter at this point in the writing process result from their assuming that the composition contains their intentions,

CHAPTER FOUR

even though this is not necessarily the case. (In other words, the writer knows what the review is supposed to say, but it just doesn't say it.) To overcome this obstacle, you must use your most discerning eye as you scrutinize your review.

Checklist: Proofreading, Revising, and Editing

As you proofread and then revise and edit your review, ask yourself these questions:

Introduction

☐ Does the introduction present specific details?

☐ Have required aspects been adequately addressed?

 (if you're writing the review in response to an instructor's assignment)

Thesis

☐ Is the thesis statement clearly stated?

☐ Are you satisfied with its location?

☐ Do you tell your reader what you intend for your review to prove?

Body

☐ Is each topic sentence easily discernible?

☐ Are you satisfied with its location?

☐ Does each body paragraph display logical unity?

☐ Is each topic adequately developed?

☐ Is each topic supported with evidence and facts?

☐ Is the organization of each body paragraph plausible?

☐ Is each body paragraph sensibly coherent?

Conclusion

☐ Does the conclusion bring the review to a close?

☐ Does it avoid introducing a new concept, idea, or topic?

☐ Does it draw an inference intended to enrich the review's discussion?

A Final Revision Step

After you've looked closely at the review's overall structure, put it aside and allow it to "rest." If a day or two are available, use them to withdraw from your review. Then, when you return to give it a final inspection, you'll be far more likely to detect problems that you'd overlooked in the previous proofreading. Use these questions as guides:

Throughout

☐ Have you provided well-constructed sentences?
☐ Have you eliminated all fragments and run-on sentences?
☐ Have you included correct punctuation?
☐ Have you carefully selected words appropriate to your topic?
☐ Are sources correctly cited?
☐ Does the review address all requirements included in the assignment?

A Sample Review

In the following selection, student-writer David Padilla reviews Willem de Kooning's *Untitled* (1969) in response to an assignment that required selecting a work of art, identifying its style, and then justifying its classification. To enhance your understanding of Padilla's comments, visit the website for the Hunter Museum of American Art <www.huntermuseum.org/index.html>, where you can see a reproduction of de Kooning's painting. On the museum's home page, follow the "collection" link, and then scroll down until you locate *Untitled*.

As you read the review, note these aspects that contribute to the review's success. In the introduction, Padilla provides a brief overview of Abstract Expressionism before informing the reader of the specific work on which his review will focus. The second paragraph examines one characteristic that confirms the painting as an example of Abstract Expressionism: its depiction of "abstracted object." The third paragraph addresses another quality found in Abstract Expressionism works: the painting's "harmony of color." And the final paragraph concludes by offering an explanation for the viewer's appreciation, which is based on reaction rather than on recognition.

Appreciation through Reaction:
de Kooning's *Untitled*

In the late 1800s, a trend moving toward Abstract Expressionism began with a move away from Realism. Artists of this period began to de-emphasize object and subject matter, and instead focused on the paint surface. More specifically, they were concerned with how the colors and textures of the paint created interest, merely giving an impression of the objects represented. This style fittingly became known as Impressionism. Cubist artists later incorporated Impressionist techniques, but they took the objects and further de-emphasized them by abstracting these objects, often to the point that they were not recognizable, focusing instead on such aspects of art as contrast, depth, surface, color, and plane. Because objects and realism had been relegated to such a minor role, it was a logical next step to ask why not eliminate them altogether? In the 1950s, Abstract Expressionism did just that. Willem de Kooning is recognized as a master of this style of painting. One of de Kooning's pieces—*Untitled*, oil on paper, mounted on board—is among the collection at the Hunter Museum of American Art in Chattanooga, Tennessee.

Like many of de Kooning's pieces, this work may not be completely freed from object, but it depicts such abstracted object that immediately recognizable forms cannot be discerned. As a result, the viewer is freed from personal associations. A sense of the beauty of the flowing human form can still be felt, however, in the flesh tone that meanders through the brighter forms in the painting, simulating human movement. Interestingly, de Kooning began his career as a figure and portrait painter; his appreciation for figure forms subtly influences this piece.

The lack of obvious subject matter in this piece allows the viewer to appreciate its harmony of color. It is dominated largely by cooler colors: blues and blue-greens. Even the pink has been cooled to a violet hue. These subdued cools are larger in form, but seem to drift in the background as a backdrop of clouds. The warm embers of color are smaller, but more intense, and they dance in the forefront. The intensity of these colors is emphasized by the energetic, seemingly erratic stroke. The combination of chaotic action with the subdued tones—as well as the forms that seem familiar but remain unrecognizable—create a mood that resembles waking from an uneasy dream.

Because no obvious object or theme is present, the viewer's appreciation of the piece is not determined by recognition, but by reaction. That being the case, every observer might react to the piece in a distinct manner. One observer might see de Kooning's painting as dreamy and sedated, while another might consider it chaotic and nerve-racking. Even the word that de Kooning selected to identify his painting is the result of a personal reaction. It is fitting that this piece is called *Untitled*; to title a piece is to assign meaning to it. No one—not even the artist who created the piece—can justifiably assign a meaning to a painting such as this, because each piece takes on its own meaning that will translate differently for each onlooker. It is this phenomenon that makes this painting a living thing. This is the beauty of Abstract Expressionism.

APPENDIX

A Selection of Museums in the United States

Following is a listing of selected art museums and galleries throughout the United States.

Alabama

Birmingham

Birmingham Museum of Art
2000 Eighth Avenue North 35203-2278
(205) 254-2566
www.artsbma.org

Visual Arts Gallery
University of Alabama at Birmingham
900 Thirteenth Street, South 35294-1260
(205) 934-0815
www.main.uab.edu

Huntsville

Huntsville Museum of Art
300 Church Street, South 35801
(800) 786-9095 (256) 535-4350
www.hsvmuseum.org/

Mobile

Mobile Museum of Art
4850 Museum Drive 36608
(251) 208-5200www.mobilemuseumofart.com/

Montgomery

Montgomery Museum of Fine Arts
Wynton M. Blount Cultural Park
One Museum Drive 36117
(334) 244-5700
www.fineartsmuseum.com/

Tuscaloosa

Sarah Moody Gallery of Art
University of Alabama
Box 870270, Garland Hall 35487-0270
(205) 348-5967
www.as.ua.edu/art/Pages/Gallery.html

Alaska

Fairbanks

University of Alaska Museum
907 Yukon Drive 99775-6960
(907) 235-8635
www.uaf.edu/museum/

Homer

Pratt Museum
3779 Bartlett Street 99603-7597
(907) 235-8635
www.prattmuseum.org/

Kodiak

Kodiak Baranov Museum
101 Marine Way 99615
(907) 486-5920
www.ptialaska.net/~baranov/index.html

Unalaska

Museum of the Aleutians
314 Salmon Way 99685
(907) 581-5150
www.aleutians.org/

Arizona

Flagstaff

Mojave Museum of History and Arts
3101 North Fort Valley Road 86001
(928) 774-5213
www.musnaz.org/

Kingman

Mojave Museum of History and Arts
400 West Beale Street 86401
(928) 753-3195
www.heard.org/

Phoenix

Heard Museum
2301 North Central Avenue 85004-1323
(602) 252-8840
www.heard.org/

Tempe

Arizona State University Art Museum
Nelson Fine Arts Center 85287
(480) 965-2787
asuartmuseum.asu.edu/home.html

Tucson

Arizona State Museum
The University of Arizona
1013 E. University Boulevard 85721-0026
(520) 621-6302
www.statemuseum.arizona.edu/

De Grazia Gallery in the Sun
6300 North Swan Road 85718
(800) 545-2185 (520) 299-9192
www.degrazia.org/

Tucson Museum of Art
140 North Main Avenue 85701
(520) 624-2333
www.tucsonarts.com/

Arkansas

Fayetteville

The Fine Arts Gallery
University of Arkansas
116 Fine Arts Center 72701
(479) 575-5202

The University Museum
University of Arkansas
202 Museum
Garland Avenue 72701
cavern.uark.edu/~museinfo/

Pine Bluff

Leedell Moorehead-Graham Fine Arts Gallery
University of Arkansas at Pine Bluff
Isaac Hathaway Fine Arts Center
1200 North University Drive 71601
(870) 543-8236
www.uapb.edu/

California

Fresno

Fresno Art Museum
2233 North First Street 93703
(559) 441-4221
www.fresnoartmuseum.com/

Fresno Metropolitan Museum
1515 Van Ness Avenue 93721-1200
(559) 441-1444
www.fresnomet.org/

Los Angeles

California African American Museum
600 State Drive 90037
(213) 744-7432
www.caam.ca.gov/

J. Paul Getty Museum
1200 Getty Center Drive 90049-1687
(310) 440-7330
www.getty.edu/museum/

The Latino Museum of History Art and Culture
201 North Los Angeles Street 90012
(213) 626-7600
www.thelatinomuseum.org/

Los Angeles County Museum of Art
5905 Wilshire Boulevard 90036
(323) 857-6000

Museum of Contemporary Art at California
Plaza
2050 South Grand Avenue 90012
(213) 626-6622
www.moca-la.org/index.php

Fowler Museum of Cultural History
University of California at Los Angeles 90095
(310) 825-4361
www.fmch.ucla.edu/

Hammer Museum
University of California at Los Angeles
10899 Wilshire Boulevard 90024
(310) 443-7020
www.hammer.ucla.edu/

Fisher Gallery
University of Southern California
823 Exposition Boulevard CA 90089-0292
(213) 740-4561
www.usc.edu/org/fishergallery/

Malibu

Frederick R. Weisman Museum of Art
Pepperdine University
24255 Pacific Coast Highway 90263
(310) 506-4000
www.pepperdine.edu/cfa/weismanmuseum.htm

APPENDIX

Pasadena

The American Museum of Beat Art
30 North Raymond Avenue 91103
(626) 683-3926
www.beatmuseum.org/

Norton Simon Art
411 West Colorado Boulevard
(626) 449-6840
www.nortonsimon.org/

Riverside

Sweeney Art Gallery
University of California, Riverside
3701 Canyon Crest Drive 92521-0113
(909) 787-3755
sweeney.ucr.edu/

San Marino

The Huntington Library, Art Collections,
 and Botanical Gardens
1151 Oxford Road
San Marino, CA 91108
(626) 405-2100
www.huntington.org/

Santa Ana

The Bowers Museum
2002 North Main Street 92706
(714) 567-3680
www.bowers.org/

Santa Cruz

The Museum of Art and History
705 Front Street
(831) 429-1964
www.santacruzmah.org/

Sacramento

Crocker Art Museum
216 O Street 95814
(916) 264-5423
www.crockerartmuseum.org/

San Diego

Museum of Contemporary Art
1001 Kettner Boulevard 92101
(619) 234-1001
www.mcasd.org/

San Diego Museum of Art
1450 El Prado 92112-2107
(619) 232-7931
www.sdmart.org/

Timken Museum of Art
1500 El Prado
Balboa Park 92101
(619) 239-5548
gort.ucsd.edu/sj/timken/

San Francisco

The Asian Art Museum
200 Larkin Street 94102
(415) 581-3500
www.asianart.org/

San Francisco Museum of Art
151 Third Street 94103-3159
(415) 357-4000
www.sfmoma.org/

San Jose

San Jose Museum of Art
110 South Market Street 95113
(408) 271-6840
www.sjmusart.org/

Stanford

Cantor Arts Center
Stanford University
328 Lomita Drive and Museum Way 94305
(650) 723-4177
www.stanford.edu/dept/ccva/

Stockton

The Haggin Museum
1201 North Pershing Avenue 95203-1699
(209) 940-6300
www.hagginmuseum.org/

Colorado

Aspen

590 North Mill Street
Aspen, Colorado 81611
(970) 925-8050
www.aspenartmuseum.org/

Boulder

CU Art Galleries
University of Colorado at Boulder
Sibell-Wolle Fine Arts Building 80309
(303) 492-8300
www.colorado.edu/cuartgalleries/cuartgal.html

Boulder Museum of Contemporary Art
1750 Thirteenth Street 80306
(303) 443-2122
www.bmoca.org/

Colorado Springs

The Gallery of Contemporary Art
University of Colorado
1420 Austin Bluffs Parkway 80918
(719) 262-3567
harpy.uccs.edu/gallery/framesgallery.html

Denver

The Denver Art Museum
100 West Fourteenth Avenue Parkway 80204
(720) 865-5000
www.denverartmuseum.org/

Museum of Contemporary Art
1275 Nineteenth Street 80202
(303) 298-7554
www.denverartmuseum.org/

Englewood

Museum of Outdoor Arts
1000 Englewood Parkway 80110
(303) 806-0444
www.moaonline.org/

Connecticut

Bridgeport

Housatonic Museum of Art, Burt
Chernow Galleries
900 Lafayette Boulevard 06604
(203) 332-5052
www.hctc.commnet.edu/artmuseum/index.html

Greenwich

The Bruce Museum of Art and Science
One Museum Drive 06830-7100
(203) 869-0376
www.brucemuseum.org/

Hartford

Artworks Gallery
233 Pearl Street 06103
(860) 247-3522
www.artworksgallery.org/

Real Art Ways
56 Arbor Street 06106
(860) 232-1006
www.realartways.org/

The Wadsworth Atheneum Museum of Art
600 Main Street 06103
(860) 278-2670
www.wadsworthatheneum.org/

Middletown

Davidson Art Center
Wesleyan University
301 High Street 06459-0487
(860) 685-2500
www.wesleyan.edu/dac/

New Britain

New Britain Museum of American Art
56 Lexington Street 06052-1412
(860) 229-0257
www.nbmaa.org/

New Canaan

Silvermine Guild Arts Center
1037 Silvermine Road 06840-4398
(203) 966-9700
www.silvermineart.org/

New Haven

Yale University Art Gallery
1111 Chapel Street 06520-8271
(203) 432-0600
www.yale.edu/artgallery/

New London

Griffis Art Center
(860) 447-3431
www.griffisartcenter.com/

APPENDIX

Old Lyme

Florence Griswold Museum
96 Lyme Street 06371
(860) 434-5542
www.flogris.org/

Lyme Academy of Fine Arts
84 Lyme Street 06371
(860) 434-5232
www.lymeacademy.edu/

Ridgefield

The Aldrich Contemporary Art Museum
258 Main Street 06877
(203) 438-4519
www.aldrichart.org/

Stamford

Center for Visual Art and Culture, Art Gallery
Broad Street and Washington Blvd 06901
(203) 251-8400

Leonhardt Galleries
Stamford Museum and Nature Center
39 Scofieldtown Road 06903
(203) 322-1646
www.stamfordmuseum.org/home.html

Storrs

Center for Visual Art and Culture
Atrium Gallery, Fine Arts Building
875 Coventry Road, RU-99 06269-1099

The William Benton Museum of Art
University of Connecticut
(860) 486-4520
www.benton.uconn.edu/

Delaware

Dover

Biggs Museum of American Art
406 Federal Street 19901-2277
(302) 674-2111
www.dovermuseums.org/museums/biggs.htm

Newark

University of Delaware Gallery
114 Old College Drive 19716-2509
(302) 831-8242
www.museums.udel.edu/art/index.html

Wilmington

Delaware Art Museum
2301 Kentmere Parkway 19806
(302) 571-9590
www.delart.org/

Delaware Center for the Contemporary Arts
200 South Madison Street 19801
(302) 656-6466
www.thedcca.org/

District of Columbia

Corcoran Gallery of Art
500 Seventeenth Street, NW 20006-4840
(202) 639-1700
www.corcoran.org/

Freer Gallery of Art
Smithsonian Institution
Jefferson Drive at Twelfth Street, SW 20013
(202) 357-4880
www.asia.si.edu/

Georgetown University Art Gallery
191 Walsh Building
1221 Thirty-Sixth Street NW 20057
(202) 687-7452
www.georgetown.edu/departments/AMT/gallery
/gallery.htm

The Kreeger Museum
2401 Foxhall Road, NW 20007
202-338-3552
www.kreegermuseum.com/

Hillwood Museum and Gardens
4155 Linnean Avenue, NW 20008
(877) HILLWOOD (202) 686-5807
www.hillwoodmuseum.org/

Hirshhorn Museum and Sculpture Garden
Smithsonian Institution
Independence Avenue at 7th Street, SW 20013
(202) 357-3091
hirshhorn.si.edu/

Howard University Gallery of Art
500 Howard Place, NW 20059
(202) 806-7234
www.howard.edu/CollegeFineArts/GALLERy_F
INAL/GalleryofArt.html

National Gallery of Art
3rd and 9th Streets at Constitution Ave, NW
20013
(202) 737-4215
www.nga.gov/

National Museum of African Art
Smithsonian Institution
950 Independence Avenue, SW 20560-0708
(202) 357-4600
www.nmafa.si.edu/

Sackler Gallery
Smithsonian Institution
1050 Independence Avenue, SW 20013
(202) 357-4880
www.asia.si.edu/

Smithsonian Institution
1000 Jefferson Drive, SW 20013
(202) 357-2700
www.si.edu/

Washington National Cathedral and Museum
Massachusetts and Wisconsin Aves, NW 20016
(202) 537-6200
www.cathedral.org/cathedral/index.shtml

Florida

Boca Raton

Boca Raton Museum of Art
Mizner Park, 501 Plaza Real 33432
(561) 392-2500
www.bocamuseum.org/

Coral Gables

The Florida Museum of
 Hispanic and Latin American Art
2206 SW Eighth Street 33135
(305) 644-1127
www.latinartmuseum.org/

Lowe Museum
University of Miami
1301 Stanford Drive 33124-6310
(305) 284-3535
www.Lowemuseum.org

Deland

African American Museum of Art
325 South Clara Avenue 32721
(386) 736-4004
www.africanmuseumdeland.org/

Fort Lauderdale

Fort Lauderdale Museum of Art
One East Las Olas Boulevard 33301
(954) 525-5500
www.museumofart.org/

Gainesville

Harn Museum of Art
University of Florida
SW Thirty-Fourth Street and Hull Road 32611
(352) 392-9826
www.arts.ufl.edu/harn/

Jacksonville

Alexander Brest Gallery and Museum
Jacksonville University
2800 University Boulevard North 32211
904) 744-3950
www.ju.edu/

Jupiter

The Hibel Museum of Art
Florida Atlantic University
5353 Parkside Drive 33458
(561) 622-5560
www.hibel.org/

Lakeland

Polk Museum of Art
800 East Palmetto Street
(863) 688-7743
www.polkmuseumofart.org/content/

Miami

Miami Center for the Fine Arts
101 W Flagler Street 33130
(305) 375-3000

Art Gallery
Miami-Dade Community College
Kendall Campus
11011 SW 104th Street 33176-3393
(305) 237-2381
www.mdcc.edu/kendall/art/

Wolfson Galleries
Miami-Dade Community College
300 NE Second Avenue 33132
(305) 237-3000
www.mdcc.edu/WOLFSON/

APPENDIX

Miami Beach

Bass Museum of Art
2121 Park Avenue 33139
(305) 673-7530
www.bassmuseum.org/

The Wolfsonian
Florida International University
1001 Washington Avenue 33139
(305) 531-1001
www.wolfsonian.fiu.edu/

North Miami

Museum of Contemporary Art
Joan Lehman Building
770 NE 125th Street
(305) 893-6211
www.mocanomi.org/

Ocala

Appleton Museum of Art
4333 NE Silver Springs Boulevard 34470
(352) 236-7100

Orlando

Orlando Museum of Art
2416 North Mills Avenue 32803-1493
(407) 896-9920
www.omart.org/

Palm Harbor

Leepa-Rattner Museum of Art
St. Petersburg Comm College atTarpon Springs
600 Klosterman Road
(727) 712-5762
www.spcollege.edu/central/museum/index.htm

Pensacola

Pensacola Museum of Art
University of West Florida
407 South Jefferson Street 32501
(850) 432-6247
www.pensacolamuseumofart.org/

St. Petersburg

Salvador Dali Museum
1000 Third Street South 33701-4901
727.823.3767
www.salvadordalimuseum.org/

Sarasota

The John and Mabel Ringling Museum of Art
5401 Bay Shore Road 34243
(941) 359-5762
www.Ringling.org

Tallahassee

Museum of Fine Arts
Florida State University
250 Fine Arts Building
Call and Copeland Streets 32306-1140
850-644-6836
www.mofa.fsu.edu./

Tampa

Contemporary Art Museum
University of South Florida
4202 East Fowler Avenue 33620
(813) 974-4133
www.usfcam.usf.edu/

Tampa Museum of Art
600 North Ashley Drive 33602
(813) 274-8130
www.tampagov.net/dept_Museum/

West Palm Beach

Norton Museum of Art
1451 South Olive Avenue 33401
(561) 832-5196
www.norton.org/

Winter Park

The Charles Hosmer Morse Museum
 of American Art
445 North Park Avenue 32789
(407) 645-5311
www.morsemuseum.org/

Cornell Fine Arts Museum
Rollins College
Holt Avenue
(407) 646-2526
www.rollins.edu/cfam/

Georgia

Athens

Georgia Museum of Art
University of Georgia
90 Carlton Street 30602-6719
(706) 542-4662
www.uga.edu/gamuseum/home.html

Atlanta

The High Museum of Art
1280 Peachtree Street, NE 30309
(404)733-4400
www.high.org/index_flash.html

Oglethorpe University
4484 Peachtree Road, NE 30319
(404) 364-8555
museum.oglethorpe.edu/

Augusta

Morris Museum of Art
One Tenth Street 30901
(706) 724-7501
www.themorris.org/

Decatur

Michael C. Carlos Museum
Emory University
571 Kilgo Circle 30322
(404) 727-4282
carlos.emory.edu/

Gainesville

Brenau University Galleries
One Centennial Circle 30501
(770) 534-6263
artsweb.brenau.edu/Galleries/

Hawaii

Honolulu

Art Gallery
University of Hawaii at Manoa
2535 The Mall 96822
(808) 956-6888
www2.hawaii.edu/artgallery/

The Contemporary Museum of Art
2411 Makiki Heights Drive 96822
(808) 526-0232
www2.hawaii.edu/artgallery/

Honolulu Academy of Arts
900 South Beretania Street 96814-1495
(808) 532-8700
www.honoluluacademy.org/

Idaho

Boise
Boise Art Museum
670 Julia Davis Drive 83702
(208) 345-8330
www.boiseartmuseum.org/

Student Union Gallery
Boise State University
1910 University Drive 83725-1335
(208) 426-4636
www.boisestate.edu/

Moscow

Prichard Art Gallery
University of Idaho
414 South Main Street 83843
(208) 885-3586
www.nevadaart.org/

Ridenbaugh Student Art Gallery
University of Idaho
Ridenbaugh Hall 83843
(208)885-6043
www.uidaho.edu/galleries/ridenbaugh/

Illinois

Bloomington

Merwin Wakely Galleries
Illinois Wesleyan University
6 Ames Plaza West
(309) 556-1000
titan.iwu.edu/~art/galler.html

Champaign

Krannert Art Museum
University of Illinois
500 East Peabody Street 61820
217-333-1860
www.art.uiuc.edu/galleries/kam/index.html

APPENDIX

Chicago

The Art Institute of Chicago
111 South Michigan Avenue 60603
(312) 443-3600
www.artic.edu/aic/index.html

The Field Museum
1400 South Lake Shore Drive 60605-2496
(312) 922-9410
www.fmnh.org/

The Martin D'Arcy Gallery of Art
Loyola University of Chicago-Lake Shore
6525 North Sheridan Road 60626
darcy.luc.edu/

Mexican Fine Arts Center Museum
1852 West Nineteenth Street 60608
(312) 738-1503
www.mfacmchicago.org/

Museum of Contemporary Art
220 East Chicago Avenue 60611
(312) 280-2660
www.mcachicago.org/welcome/

Northern Illinois University Art Museum
Chicago Gallery
215 Superior Street 60610
(312) 642-6010
www.vpa.niu.edu/museum/

Dekalb

Northern Illinois University Art Museum
Altgeld Hall 60115
(815) 753-1936
www.vpa.niu.edu/museum/

Evanston

Mary and Leigh Block Museum of Art
Northwestern University
40 Arts Circle Drive 60208-2410
(847) 491-4000
www.blockmuseum.northwestern.edu/
index.html

Normal

University Galleries
Illinois State University
110 Center for Visual Arts 61790-5620
(309) 438-5487
www.arts.ilstu.edu/cfa/galleries/

Peoria

Heuser Art Center
Bradley University
1501 West Bradley Avenue 61625
(309) 676-7611

Springfield

Illinois State Museum
Spring and Edward Streets 62706-5000
(217) 782-7387
www.museum.state.il.us/ismsites/main/

Urbana

Spurlock Museum
University of Illinois at Urbana-Champaign
600 South Gregory Street 61801
(217) 333-2360
www.spurlock.uiuc.edu/

World Heritage Museum
University of Illinois
484 Lincoln Hall, 702 Wright Street 61820
(217) 333-2360
www.uiuc.edu/index.html

Indiana

Bloomington

Indiana University Art Museum
1133 East Seventh Street 47405-7509
(812) 855-5445
www.indiana.edu/~iuam/

Gary

IUN Gallery for Contemporary Art
and Gallery Northwest
Indiana University Northwest
3400 Broadway 46408
(888) 968-7486 (219) 980-6891
www.iun.edu/~gallery/

Indianapolis

Eiteljorg Museum of
American Indian and Western Art
500 West Washington Street 46204
(317) 636-9378
www.eiteljorg.org/

Indianapolis Museum of Art
4000 Michigan Road 46208-3326
(317) 920-2660
www.ima-art.org/

IUPUI Herron's Gallery
Indiana Univ-Purdue Univ Indianapolis
1701 North Pennsylvania Street
(317) 920-2420
www.herron.iupui.edu/newlow/gallery/

Kokomo

IU Kokomo Art Gallery
Indiana University Kokomo
2300 South Washington Street 46904
(765) 455-9523
www.iuk.edu/ARTGALLERY/

Lafayette

Art Museum of Greater Lafayette
102 South Tenth Street 47905
(765) 742-1128
www.dcwi.com/~glma/

Muncie

Atrium Gallery
Ball State University
Art and Journalism Building 47306
www.bsu.edu/cfa/art/gallery/Atrium/

Museum of Art
Ball State University
College of Fine Arts
Riverside Avenue at Warwick Road 47306
(765) 285-5242
www.bsu.edu/web/cfa/artmuseum/

Notre Dame

The Snite Museum of Art
University of Notre Dame
Notre Dame 46556-0368
(574) 631-5466
www.nd.edu/~sniteart/index.html

Richmond

Richmond Art Museum
350 Hub Etchison Parkway 47374-0816
(765) 966-0256
www.richmondartmuseum.org/

South Bend

South Ben Regional Museum of Art
120 South Street 46601
(574) 235-9102
www.sbt.infi.net/~sbrma/

Terre Haute

The Art Gallery
Center for Performing and Fine Arts
Indiana State University
47809
baby.indstate.edu/art_sci/art/Gallery.htm

West Lafayette

Purdue University Galleries
Purdue Memorial Union 47907
(765) 496-7899
engineering.purdue.edu/Galleries/
 exhibitions/000012

Iowa

Ames

Brunnier Art Museum
Iowa State University
290 Scheman Building 50011-1110
(515) 294-3342
www.museums.iastate.edu/
 BrunnierFrames.htm

Cedar Falls

James and Meryl Hearst Center for the Arts
304 West Seerley Boulevard IA 50613
(319) 273-8641
www.ci.cedar-falls.ia.us/human_leisure/
 hearst_center/

Des Moines

Des Moines Art Center
4700 Grand Avenue 50312-2099
(515) 277-4405
www.desmoinesartcenter.org/home.html

Iowa City

Museum of Art
University of Iowa
150 North Riverside Drive 52242-1789
(319) 335-1727
www.uiowa.edu/uima/

APPENDIX

Kansas

Lawrence

Spencer Museum of Art
University of Kansas
1301 Mississippi Street 66045
785/864-4710
www.ku.edu/~sma/

Lindsborg

Birger Sandzen Memorial Gallery
401 North First Street 67456
(785) 227-2220
www.sandzen.org/

Manhatten

Beach Museum of Art
Kansas State University
701 Beach Lane 66506
(785) 532-7718
www.ksu.edu/bma/

Wichita

Wichita Art Museum
619 Stackman Drive 67203
(316) 268-4921
www.wichitaartmuseum.org/

Edwin A Ulrich Museum of Art
Wichita State University
1845 Fairmount 67260-0046
(316) 978-3664

Kentucky

Bowling Green

The Kentucky Museum
Western Kentucky University
Kentucky Building 42101-3576
(270) 745-2592
www.wku.edu/Library/museum/

Lexington

University of Kentucky Art Museum
Rose Street and Euclid Avenue 40506-0241
(859) 257-5716
www.uky.edu/ArtMuseum/

Louisville

Louisville Visual Art Association
3005 River Road 40207
(502) 896-2146
www.louisvillevisualart.org/index.htm

The Speed Art Museum
2035 South Third Street 40208
(502) 634-2700
www.louisvillevisualart.org/index.htm

Murray

The Clara M. Eagle Gallery
Murray State University
Price Doyle Fine Arts Center 42071-0009
(270) 762-3052

Louisiana

Alexandria

Alexandria Museum of Art
933 Main Street 71391-1028
(318)443-3458
www.themuseum.org/

Louisiana State University at Alexandria Gallery
Student Center
Highway 71 South 71302
(318) 445-3672
www.lsua.edu/index_2.html

New Orleans

Arthur Roger Gallery
432 Julia Street 70130
(504) 522-1999
www.arthurrogergallery.com/

Contemporary Arts Center
900 Camp Street 70130
504 528 3805
www.cacno.org/index.html

New Orleans Museum of Art
One Collins Diboll Circle 70124
(504) 488-2631
www.noma.org/index.cfm

Shreveport

Casa d'Arte Gallery of Fine Art
214 Texas Street 71101
(318) 424-6415
www.casadarte.com/

Meadows Museum of Art
Centenary College of Louisiana
2911 Centenary Boulevard 71104
(318) 869-5169
www.centenary.edu/departme/meadows/

R. W. Norton Museum
Centenary College
4747 Creswell Avenue 71106-1899
(318) 865-4201
www.softdisk.com/comp/norton/

Maine

Brunswick

Bowdoin College Museum of Art
9400 College Station 04011-8494
(207) 725-3275
academic.bowdoin.edu/artmuseum/

Portland

Portland Museum of Art
Seven Congress Square 04101
(207) 775-6148
www.portlandmuseum.org/

Rockland

The Farnsworth Art Museum & Wyeth Center
16 Museum Street 04841
(207) 596-6457
farnsworthmuseum.org/

Waterville

Museum of Art
Colby College
5600 Mayflower Hill Drive 04901
(207) 872-3228
www.colby.edu/museum/

Maryland

Baltimore

American Visionary Museum
800 Key Highway 21230
(410) 244-1900
www.avam.org/

The Baltimore Museum of Art
Art Museum Drive 21218-3898
(410) 396-7100
www.artbma.org/

The Walters Art Gallery
600 North Charles Street 21201
(410) 547-9000
www.thewalters.org/

Adelphi

The Herman Maril Gallery
University of Maryland University College
3501 University Boulevard East 20783
(800) 888-UMUC
www.umuc.edu/maril/maril_main.html

Salisbury

The Ward Museum of Waterfowl Art
909 South Schumaker Drive 21804
(410) 742-3107
www.wardmuseum.org/

Massachusetts

Amherst

Amherst College Mead Art Museum
Amherst College
P.O. Box 5000
Amherst, MA 01002-5000
(413) 542-2335
www.amherst.edu/~mead/

Herter Art Gallery
University of Massachusetts Amherst
125A Herter Hall 01003
(413) 545-0111
www.umass.edu/

Boston

Isabella Steward Gardner Museum
280 The Fenway 02115
(617) 566-1401
www.gardnermuseum.org/index.asp

Museum of Fine Arts
Avenue of the Arts
465 Huntington Avenue 02115-5523
(617) 267-9300
www.mfa.org/home.htm

APPENDIX

Cambridge

Arthur M. Sackler Museum
Busch-Reisinger Museum
Fogg Art Museum
Harvard University
32 Quincy Street 02138
(617) 495-9400
www.artmuseums.harvard.edu/

Chestnut Hill

McMullen Museum of Art
Boston College
Devlin Hall 108
140 Commonwealth 02467
www.bc.edu/bc_org/avp/cas/artmuseum/

Framingham

Danforth Museum of Art
123 Union Avenue 01701-8291
(508) 620-0050
www.danforthmuseum.org/dma_live/
 dma_default.html

Lincoln

DeCordova Museum and Sculpture Park
51 Sandy Pond Road 01773
(781) 259-8355
www.decordova.org/

Northhampton

Smith College Museum of Art
Elm Street
Northampton, Massachusetts 01063
(413) 585.2760

Springfield

Dr. Seuss National Memorial Sculpture Garden
The Springfield Museums of the Quadrangle
Corner of State and Chestnut Streets 01103
(413) 263-6800
www.catinthehat.org/

George Walter Vincent Smith Art Museum
The Springfield Museums of the Quadrangle
Corner of State and Chestnut Streets 01103
(413) 263-6800
www.quadrangle.org/GWVS.htm

Museum of Fine Arts
The Springfield Museums of the Quadrangle
Corner of State and Chestnut Streets 01103
(413) 263-6800
www.quadrangle.org/MFA.htm

Waltham

Brandeis University Rose Art Museum
415 South Street 02454-9110
(781) 736-3434
www.brandeis.edu/rose/

Worcester

Worcester Art Museum
55 Salisbury Road 01609
(508) 799-4406
www.worcesterart.org/

Michigan

Ann Arbor

The Museum of Art
The University of Michigan
525 South State Street 48109
(734) 764-0395
www.dia.org/

Detroit

Detroit Institute of Arts
5200 Woodward Avenue 48202
(313) 833-7900
www.dia.org/

Grand Rapids

Grand Rapids Arts Museum
155 Division North 49503-3154
(616) 831-1000
www.gramonline.org/

Kalamazoo

Kalamazoo Institute of Arts
314 South Park Street 49007
(269) 349-7775
www.kiarts.org/

East Lansing

Michigan State University Museum
West Circle Drive 48824-1045
(517) 355-7474
museum.msu.edu/

Minnesota

Duluth

Tweed Museum of Art
University of Minnesota at Duluth
1201 Ordean Court
10 University Drive 55812
(218) 726-8222
www.d.umn.edu/tma/

Minneapolis

Minneapolis Institute of Arts
2400 Third Avenue South 55404
(612) 870-3131
www.artsmia.org/

Frederick R. Weisman Art Museum
University of Minneapolis
333 East River Road 55455
(612) 625-9494
hudson.acad.umn.edu/

Walker Art Center
725 Vineland Place 55403
(612) 375-7622
www.walkerart.org/jsindex.html

St. Paul

Minnesota Museum of American Art
505 Landmark Center
75 West Fifth Street 55102
(651) 292-4355
www.mmaa.org/

Mississippi

Biloxi

The Ohr-O'Keefe Museum of Art
136 G. E. Ohr Street 39530
(228) 374-5547
www.georgeohr.org/

Jackson

Mississippi Museum of Art
201 East Pascagoula Street 39201
(866) VIEW ART
www.msmuseumart.org/

Ocean Springs

Walter Anderson Museum of Art
510 Washington Avenue 39564-4632
(228) 872-3164
www.walterandersonmuseum.org/

University

University Museums
The University of Mississippi
Fifth Street and University Avenue 38655
38677
(662) 915-7073
www.olemiss.edu/depts/classics/museums.html

Missouri

Columbia

Museum of Art and Architecture
University of Missouri-Columbia
Ninth Street and University Ave 65211
(573) 882-3591
museum.research.missouri.edu/

Kansas City

Kemper Museum
4420 Warwick Boulevard 64111-1821
(816) 561-3737
www.kemperart.org/

The Nelson-Atkins Museum of Art
4525 Oak Street 64111-1873
(816) 751-1278
www.nelson-atkins.org/

St. Louis

Museum of Art
St. Louis University
O'Donnell Hall
3663 Lindell Boulevard 63103
(314) 977-3399
sluma.slu.edu/

Springfield

Art and Design Gallery
Southwest Missouri State University
333 East Walnut Street
(417) 866-4861
art.smsu.edu/resources/
 art_design_gallery.html

APPENDIX

Montana

Great Falls

 C. M. Russell Museum
 400 Thirteenth Street North 59401-1498
 (406) 727-8787
 www.cmrussell.org/

Missoula

 Art Museum of Missoula
 335 North Pattee 59802
 (406) 728-0447
 www.artmissoula.org/

 Museum of Art and Culture
 University of Montana Missoula
 School of Fine Arts
 Radio / Television Center 59812
 (406) 243-2019
 www.umt.edu/partv/famus/

Nebraska

Lincoln

 Sheldon Memorial Art Gallery
 and Sculpture Garden
 University of Nebraska
 Twelfth and R Streets 68588-0300
 (402) 474-2461
 www.sheldonartgallery.org/

Omaha

 Joslyn Art Museum
 2200 Dodge Street 68102-1292
 (402) 343-3400
 www.joslyn.org/

Nevada

Las Vegas

 Donna Beam Fine Art Gallery
 University of Nevada at Las Vegas
 Alta Ham Fine Arts Building
 (702) 895-3893
 www.unlv.edu/Colleges/Fine_Arts/Facilities/
 Donna_Beam_Gallery/DonnaBeam.html

Reno

 Nevada Museum of Art
 160 West Liberty Street 89501
 (775) 329-3333
 www.nevadaart.org/

 Sheppard Art Gallery
 University of Nevada at Reno
 Church Fine Arts Building
 (775) 784-6658

New Hampshire

Cornish

 Saint-Gaudens National Historic Site
 139 Saint Gaudens Road 03745
 (603) 675-2175
 www.sgnhs.org/

Durham

 The Art Gallery
 University of New Hampshire
 Paul Creative Arts Center 03824
 (603) 862-3712
 www.unh.edu/art-gallery.html

Hanover

 Dartmouth College Hood Museum of Art
 Wheelock Street 03755
 (603) 646-2808
 www.dartmouth.edu/~hood/

Manchester

 Currier Museum of Art
 201 Myrtle Way 03104
 (603) 669-6144
 www.currier.org/

New Jersey

Montclair

 The Montclair Art Museum
 3 South Mountain Avenue 07042-1747
 (973) 746- 5555
 www.montclair-art.com/

Morristown

The Morris Museum
6 Normandy Heights Road 07960
(973) 971-3700
www.morrismuseum.org/

Newark

The Newark Museum
49 Washington Street 07102-3176
(973) 596-6550
www.newarkmuseum.org/

Oceanville

The Noyes Museum of Art
Lily Lake Road 08231-0489
(609) 652-8848
www.noyesmuseum.org/

Trenton

New Jersey State Museum
205 West State Street 08625-0530
(609) 292-6301
www.state.nj.us/state/museum/

New Mexico

Albuquerque

The Albuquerque Museum
2000 Mountain Road NW 87104
(505) 243-7255
www.cabq.gov/museum/

University Art Museum
The University of New Mexico
Center for the Arts 87131-1416
(505) 277-4001
unmartmuseum.unm.edu/

Las Cruces

New Mexico State University Art Gallery
Williams Hall
University Avenue 88003-0001
(505) 646-2545
www.nmsu.edu/Campus_Life/artgal.html

Sante Fe

Institute of American Indian Arts
83 Avan Nu Po Road 87505
(505) 424-2300
www.iaiancad.org/

Museum of Fine Arts
107 West Palace Avenue 87501
(505) 476-5001
www.museumofnewmexico.org/

Museum of Indian Arts and Culture
Camino Lejo 87505
(505) 476-1250
\www.miaclab.org/indexfl.html

Museum of International Folk Art
Camino Lejo 87505
(505) 476-1200
www.moifa.org/

New York

Buffalo

Albright-Knox Art Gallery
1285 Elmwood Avenue 14222-1096
(716) 882-1958
www.albrightknox.org/phillips_index.html

New York

The Cloisters
Fort Tyron Park 10040
(212) 923-3700
www.metmuseum.org/collections/
 department.asp?dep=7

The Frick Collection & Art Reference Library
One East Seventieth Street 10021-4967
212-288-0700
www.frick.org/

The Metropolitan Museum of Art
1000 Fifth Avenue 10028-0198
(212) 535-7710
www.metmuseum.org/home.asp

The Museum of Modern Art
11 West 53rd Street 10019
(212) 708-9400
www.moma.org/

North Carolina

Asheville

Asheville Art Museum
2 South Pack Square 28802-1717
(828) 253.3227
www.ashevilleart.org/

APPENDIX

Boone

Catherine Smith Gallery
Appalachian State University
Farthing Auditorium
River Street 28608
(828) 262-6084
www.oca.appstate.edu/csg/

Brevard

Spiers Gallery
Brevard College
Sims Art Building
400 North Broad Street 28712
(828) 884-8188
tornado.brevard.edu/art/

Chapel Hill

Ackland Art Museum
University of North Carolina at Chapel Hill
Columbia Street 27599-3400
(919) 966-5736
www.ackland.org/visit/index.html

Charlotte

Jerald Melberg Gallery
3900 Colony Road 28211
(704) 365-3000
www.jeraldmelberg.com/

Mint Museum of Art
2730 Randolph Road 28207
(704) 337-2000
www.mintmuseum.org/

Durham

Duke University Museum of Art
East Campus
Buchanan Boulevard at Trinity Ave 10040
(919) 684-5135
www.duke.edu/web/duma/

Fayetteville

Faryetteville Museum of Art
839 Stamper Road
Fayetteville 28303
(919) 485-5121
www.fayettevillemuseumart.org/

Greensboro

Green Hill Center for North Carolina Art
200 North Davie Street 27401
(336) 333-7460
www.greenhillcenter.org/

Guilford College Art Galley
Hege Library
5800 West Friendly Avenue 27410
(336) 316-2438
www.ackland.org/visit/index.html

Weatherspoon Art Museum
University of North Carolina-Greensboro
Spring Garden and Tate Streets 27402-6170
(336) 334-5770
www.uncg.edu/wag/

Wellington B. Gray Gallery
East Carolina University
Fifth Street 27858
(252) 328-6336
www.ecu.edu/graygallery/

Hickory

Hickory Museum of Art
243 Third Avenue NE 28601
(828) 327-8576
www.hickorymuseumofart.org/

Raleigh

Artspace
201 East Davie Street 27601
(919) 821-2787
artspace.citysearch.com/

North Carolina Museum of Art
2110 Blue Ridge Road 27607-6494
(919) 839-6262
ncartmuseum.org/

Gallery of Art and Design
North Carolina State University
Cates Avenue 27695-7306
(919) 515-3503
www.duke.edu/web/duma/

Salisbury

Waterworks Visual Arts Center
123 East Liberty Street 28144
(704) 636-1882
www.waterworks.org/pages/1/index.htm

Wilmington

Louis Wells Cameron Art Museum
3201 South Seventh Street 28412
(910) 395-5999
www.stjohnsmuseum.com/

Winston-Salem

Diggs Gallery
Winston-Salem State University
C. G. O'Kelly Library 27110-0001
(336) 750-2458
www.wssu.edu/diggs/home.asp

Charlotte and Philip Hanes Art Gallery
Wake Forest University
Scales Fine Arts Center 27106
(336) 758-5795
www.wfu.edu/Academic-departments/
Art/gall_index.html

Reynolda House, Museum of Art
2250 Reynolda Road 27106
(888) 663-1149 (336) 725-5325
www.reynoldahouse.org/ie.html

Sawtooth Center for Visual Art
226 North Marshall Street 27101
(336) 723-7395
www.sawtooth.org/

North Dakota

Bismarck

Gannon and Elsa Forde Galleries
Bismarck State College
1500 Edwards Avenue 58506
(800) 445-5073 (701) 224-5520
www.bismarckstate.edu/faculty/art/gallery.htm

Fargo

Memorial Union Gallery
North Dakota State University
Administration Avenue 58105
(701) 231-7900
www.ndsu.nodak.edu/memorial_union/gallery/

Plains Art Museum
704 First Avenue North 58102
(701) 232-3821
www.plainsart.org/

Grand Forks

North Dakota Museum of Art
Centennial Drive 58202
PO Box 7305 58202-7305
www.ndmoa.com/

Minot

Lillian and Coleman Taube Museum of Art
2 North Main 58702
(701) 838-4445
www.ndaga.org/Galleries/tma.html

Ohio

Akron

Akron Art Museum
70 East Market Street 44308-2084
(330) 376-9185
www.akronartmuseum.org/

Athens

Kennedy Museum of Art
Ohio University
Lin Hall 45701
(740) 593-1304
www.ohiou.edu/museum/

Ohio University Art Gallery
528 Seigfred Hall 45701
(740) 593-0796
www.cats.ohiou.edu/art/index.html

Canton

Canton Museum of Art
1001 Market Avenue North
(330) 453-7666
www.neo.rr.com/cma/

Cincinnati

Cincinnati Museum of Art
953 Eden Park 45202
(513) 721-2787
www.cincinnatiartmuseum.org/

The Contemporary Arts Center
115 East Fifth Street 45202
(513) 345-8400
www.contemporaryartscenter.org/

APPENDIX

Cleveland

Cleveland Center for Contemporary Art
8501 Carnegie Avenue 44106
(216) 421-8671
www.mocacleveland.org/

Cleveland Institute of Art
University Circle
11141 East Boulevard 44106-1710
(800) 223-4700 (216) 421-7000
www.cia.edu/

Cleveland Museum of Art
11150 East Boulevard 44106
(216) 421-7340
www.clemusart.com/

Cleveland State University Art Gallery
2307 Chester Avenue 44114
(216) 687-2103
www.csuohio.edu/art/gallery/

Columbus

Columbus Museum of Art
480 East Broad Street 43215
(614) 221-6801
www.columbusmuseum.org/

Wexner Center for the Arts
The Ohio State University
1871 North High Street 43210-1393
(614) 292-3535
www.wexarts.org/

Dayton

Dayton Art Institute
456 Belmonte Park North 45405-4700
(800) 296-4426 (937) 223-5277
www.daytonartinstitute.org/

Dayton Visual Arts Center
40 West Fourth Centre 45402-0416
(937) 224-3822
www.sinclair.edu/dvac/home.htm

The Robert J. Shiffler Foundation
7695 Poe Avenue 45414-2552
(937) 547-0271
www.bobsart.org/

Oberlin

The Allen Memorial Art Museum
Oberlin College
87 North Main Street 44074
(440) 775-8665
www.oberlin.edu/allenart/

Oxford

Miami University Art Museum
801 South Patterson Avenue 45056
(513) 529-2232
www.fna.muohio.edu/amu/

Toledo

Miami University Art Museum
2445 Monroe St at Scottwood Ave 43620
(800) 644-6862 (419) 255-8000
www.toledomuseum.org/home.html

Wooster

Ebert Art Center
The College of Wooster
1220 Beall Avenue 44691
(330) 263-2495
www.wooster.edu/art/

Youngstown

Butler Institute of American Art
524 Wick Avenue 44502
(330) 743-1711
www.butlerart.com/butler_youngstown.htm

John J. McDonough Museum of Art
Youngstown State University
One University Plaza 44555
(330) 742-3627
www.fpa.ysu.edu/mcdonough/history.html

Oklahoma

Norman

Fred Jones, Jr., Museum of Art
University of Oklahoma
410 West Boyd Street 73019
(405) 325-3272
www.ou.edu/fjjma

Oklahoma City

Oklahoma City Art Museum
415 Couch Drive 73102
(800) 579-9ART (405) 236-3100
www.okcartmuseum.com/

Tulsa

Gilcrease Museum
1400 North Gilcrease Museum Rd 74127
(918) 596-2700
www.gilcrease.org/

Philbrook Museum of Art
2727 South Rockford Road 74114
(800) 324-7941 (918) 748 5309
www.philbrook.org/DesktopDefault.aspx

Oregon

Ashland

Schneider Museum of Art
Southern University State College
1250 Siskiyou Boulevard 97403-1223
(541) 552-6245
www.sou.edu/sma/

Coos Bay

Coos Bay Museum
235 Anderson Avenue 97420
(541) 267-3901
www.coosart.org/

Eugene

Museum of Art
University of Oregon
1430 Johnson Lane 97403-1223
(541) 346-3027
uoma.uoregon.edu/

Lane Community College Art Gallery
4000 East Thirtieth Avenue 97405
(541) 463-5409
www.lanecc.edu/artad/gallery/gallery.htm

Grants Pass

Museum of Art
229 SW 'G' Street 97526
541-479-3290

Hood River

International Museum of Carousel Art
304 Oak Street 97031
541-387-4622
www.carouselmuseum.com/

Marylhurst

The Art Gym
Marylhurst University
17600 Pacific Highway 97036-0261
(800) 634-9982 (503) 699-6243
www.marylhurst.edu/artgym/index.html

Portland

Buckley Center Gallery
University of Portland
5000 North Willamette Boulevard
(503) 283-7258
www.uofport.edu/

Hoffman Gallery
Oregon School of Arts and Crafts
8245 Southwest Barnes Road
(800) 390-0632 (503) 297-5544
www.ocac.edu/

Littman Gallery
Portland State University
1802 Southwest Tenth Avenue 97207
(503) 725-5656

Northview Gallery
Portland Community College
12000 SW 49th Street 97219
(503) 977-4269
www.pcc.edu/

Philip Feldman Gallery
Pacific Northwest College of Art
1241 NW Johnson Street 97209
(503) 226-4391
www.pnca.edu/

Portland Art Museum
1219 Southwest Park Avenue 97205
(503) 226-2811
www.pam.org/

Portland Institute for Contemporary Art
219 Northwest Twelfth Avenue 97209
(503) 242-1419
www.pica.org/index_fl.html

Douglas F. Cooley Memorial Art Gallery
Reed College
3202 Southeast Woodstock Blvd. 97202
(503) 771-1112
web.reed.edu/gallery/

Pennsylvania

Bethlehem

Art Galleries
Lehigh University
Zoellner Arts Center
420 East Packer Avenue 18015-3006
(610) 758-2787
www3.lehigh.edu/zoellner/

Chadds Ford

Brandywine River Museum
U.S. Route 1 and PA Route 100 19317
(610) 388-8382
www.brandywinemuseum.org

Doylestown

James A. Michener Art Museum
138 South Pine Street 18901
(215) 340-9800
www.michenerartmuseum.org/

Erie

Erie Art Museum
411 State Street 16501
(814)459-5477
www.erieartmuseum.org/

Greensburg

Westmoreland Museum of American Art
221 North Main Street 15601
(724) 837-1500
www.wmuseumaa.org/

Harrisburg

The State Museum of Pennsylvania
300 North Street 17120
(717) 787-4979
www.statemuseumpa.org/

Merion

The Barnes Foundation
300 North Latch's Lane 19066
(610) 667-0290
www.barnesfoundation.org/

Philadelphia

Lasalle University Art Museum
1900 West Olney Avenue 19141
(215) 951-1221
www.lasalle.edu/services/art-mus/

Moore College of Art and Design
20th Street and The Parkway
(215) 965-4045
thegalleriesatmoore.org/
 index.shtml

Pennsylvania Academy of the Fine Arts
118 North Broad Street 19102
(215) 972-7600
www.pafa.org/splashFlash.jsp

Philadelphia Museum of Art
Benjamin Franklin Parkway and
26th Street 19130
(215) 763-8100
www.philamuseum.org/

University of Philadelphia Arthur Ross Gallery
220 South 34th Street 19130
(215) 898-2083
www.upenn.edu/ARG/

Pittsburgh

The Carnegie Museum of Art
4400 Forbes Avenue 15213-4080
(412) 622-3131
www.cmoa.org/

Elkins Park

Tyler School of Art Galleries
Temple University
7725 Penrose Avenue 19027
(215) 782-2828
www.temple.edu/tyler/exhibit_galleries.htm

Reading

Reading Public Museum
500 Museum Road 19611
(610) 371-5850
www.readingpublicmuseum.org/

University Park

Palmer Museum of Art
Pennsylvania State University
Curtin Road 16802
(814) 865-7672
www.psu.edu/dept/palmermuseum/

Rhode Island

Kingston

Fine Arts Center Galleries
University of Rhode Island
105 Upper College Road 02881-0820
(401) 874-2627
www.uri.edu/artgalleries/

Newport

Newport Art Museum
76 Bellevue Avenue 02840
(401) 848-2787
www.newportartmuseum.com/

Providence

Edward Mitchell Bannister Gallery
Rhode Island College
Roberts Hall
600 Mt. Pleasant Avenue 02908
(401) 456-9765
www.ric.edu/bannister/

David Winton Bell Gallery
Brown University
64 College Street 02912
(401) 863-2932
www.brown.edu/Facilities/
 David_Winton_Bell_Gallery/

Museum of Art
Rhode Island School of Design
224 Benefit Street 02903
(401) 454-6500
www.risd.edu/museum.cfm

South Carolina

Charleston

Gibbes Museum of Art
135 Meeting Street 29401
(843) 722-2706
www.gibbes.com/

Columbia

Columbia Museum of Art
Main and Hampton Streets 29202
(803) 799-2810
www.colmusart.org/

McKissick Museum
University of South Carolina
816 Bull Street 29208
(803) 777-7251
www.cla.sc.edu/MCKS/index.html

South Carolina State Museum
301 Gervais Street 29202
(803) 7374921
www.museum.state.sc.us/

Greeneville

Bob Jones University Museum and Gallery
1700 Wade Hampton Boulevard 29614
(864) 242-5100
www.bju.edu/gallery/index.htm

Spartanburg

Art Gallery
University of South Carolina-Spartanburg
800 University Way 97205
(864) 503-5838
www.uscs.edu/

Milliken Gallery
Converse College
580 East Main Street 29302
(864) 596-9177
www.sparklenet.com/conversecollege/art/

South Dakota

Brookings

South Dakota Art Museum
Medary Ave at Harvey Dunn
57007
(605) 688-5423
www3.sdstate.edu/Administration/
 SouthDakotaArtMuseum/

Mobridge

Klein Museum Art Gallery
1820 West Grand Crossing 57601
(605) 845-7243
www.thedahl.org/

APPENDIX

Rapid City

Dahl Arts Center
713 Seventh Street 57701-3695
(605) 394-4101
www.thedahl.org/

Vermillion

University Art Galleries
University of South Dakota
(605) 677-5481
www.usd.edu/museums.cfm

Tennessee

Chattanooga
Hunter Museum of American Art
10 Bluff View 37403-1197
(423) 267-0968
www.huntermuseum.org/

Cress Gallery of Art
University of Tennessee at Chattanooga
Vine and Palmetto Streets 37403
(423) 755-4600
www.utc.edu/cressgallery/

Jackson

University Art Galley
Union University
1050 Union University Drive 37614
(901) 661-5075
www.uu.edu/dept/art/gallery/

Jefferson City

Omega Gallery
Carson-Newman College
1646 Russell Avenue 37760
(865) 471-2000
www.cn.edu/academics/departments/
art/exhibit.html

Johnson City

Carroll Reece Museum
East Tennessee State University
Stout Drive 37614
(423) 439-4392
cass.etsu.edu/museum/

Slocumb Galleries
East Tennessee State University
Ball Hall
Sherrod Street 37614-0708
(423) 439-7078
www.slocumb.org/

Knoxville

Knoxville Museum of Art
1050 World's Fair Park 37916-1653
(865) 525-6101
www.knoxart.org/

Frank H. McClung Museum
University of Tennessee
1327 Circle Park Drive 37996-3200
(865) 974-2144
mcclungmuseum.utk.edu/

Memphis

Memphis Brooks Museum of Art
1934 Poplar Avenue 38104
(901) 544-6200
www.brooksmuseum.org/

Art Museum of the University of Memphis
142 Fine Arts Building 38152
(901) 678-2224
www.people.memphis.edu/~artmuseum/
amhome.html

Institute of Egyptian Art and Architecture
University of Memphis
Communication and Fine Arts Building
3750 Norriswood Avenue 38152
(901) 678-2555
www.memphis.edu/egypt/main.html

Nashville

Cheekwood Museum of Art
1200 Forrest Park Drive 37207
(615) 356-8000
www.cheekwood.org/index.html

Carl Van Vechten and Aaron Douglas Galleries
Fisk University
1000 Seventh Avenue North
(615) 329-8720
www.fisk.edu/index.asp

Fine Art Gallery
Vanderbilt University
23rd Street and West End Avenue 37203
(615) 322-0605
sitemason.vanderbilt.edu/gallery

Frist Center for the Visual Arts
919 Broadway 37203
(615) 244-3340
www.fristcenter.org/

Tennessee State Museum
Fifth and Deaderick Streets
Nashville, TN 37243-1120
(800) 407-4324 (615) 741-2692

Sewanee

University Art Gallery
University of the South
735 University Avenue 37383
(931) 598-1000

Texas

Austin

Austin Museum of Art
Fourth and Guadalupe Streets
(512) 495-9224
www.amoa.org/

Jack S. Blanton Museum of Art
University of Texas at Austin
23rd Street and San Jacinto Blvd 78712
(512) 471-7324
www.blantonmuseum.org/

Beaumont

Art Museum of Southeast Texas
500 Main Street 77701
(409) 832-3432
www.amset.org/

College Station

J. Wayne Stark University Center Galleries
Texas A & M University
Memorial Student Center 77843
(979) 845-8501
www.usd.edu/museums.cfm

Dallas

Dallas Museum of Art
1717 North Harwood 75201
(214) 922-1200
www.dm-art.org/

Meadows Museum
Southern Methodist University
5900 Bishop Boulevard 75275-0357
(214) 768-2516

El Paso

One Arts Festival Plaza
El Paso, Texas 79901
(915) 532-1701

Fort Worth

Amon Carter Museum
3501 Camp Bowie Boulevard 76107-2695
(817)738-1933
www.cartermuseum.org

Kimbell Art Museum
3333 Camp Bowie Boulevard 76107-2792
817-332-8451
www.kimbellart.org/

Modern Art Museum
3200 Darnell Street 76107
(866) 824-5566 (817) 738-9215
www.mamfw.org/

Houston

Blaffer Gallery
University of Houston
120 Fine Arts Building 77204-4018
(713) 743-9530
www.hfac.uh.edu/blaffer/

Contemporary Arts Museum
5216 Montrose Boulevard 77006-6598
(713) 284-8250
www.camh.org/

Museum of Fine Arts
1001 Bissonnet Street 77005
(713) 639-7300
www.mfah.org/main.asp

APPENDIX

Rice Gallery
Rice University
6100 Main Street 77005
(713) 348-6069
www.ruf.rice.edu/~ruag/

Longview

Longview Museum of Fine Arts
215 East Tyler Street 75601
(903) 753-8103
www.lmfa.org/

Lubbock

Landmark School of Art
Texas Tech University
18th and Flint Streets 79409-2081
(806) 742-3825
www.art.ttu.edu/artdept/lndmrk.html

San Antonio

ArtPace
445 North Main Avenue 78205-1441
(210) 212-4900
www.artpace.org/home.html

The Marion Koogler McNay Art Museum
6000 North New Braunfels 78209
(210)824-5368
www.mcnayart.org

Museum of Art
200 West Jones Avenue 78215
(210) 978-8100
www.sa-museum.org/

Utah

Cedar City

Braithwaite Fine Arts Gallery
351 West Center Street
(435) 586-5432
www.suu.edu/pva/artgallery/

Provo

Brigham Young University Museum of Fine Arts
North Campus Drive 84602
(801) 422-8287
cfac.byu.edu/moa/

Salt Lake City

University of Utah Museum of Fine Arts
410 Campus Center Drive 84112-0350
(801) 581-7332
www.umfa.utah.edu/

Springville

Springville Museum of Art
126 East 400 South 84663
(801) 489-2727
www.shs.nebo.edu/museum/museum.html

Vermont

Burlington

University of Vermont Fleming Museum
61 Colchester Avenue 05405
(802) 656-0750
www.flemingmuseum.org

Middlebury

Middlebury College Museum of Art
Center for the Arts 05753
(802) 443-5007
www.middlebury.edu/~museum/

Montpelier

T. W. Wood Gallery and Arts Center
Vermont College
College Hall 05602
(802) 223-8743
www.vmga.org/washington/wood.html

Virginia

Charlottesville

Bayly Art Museum
University of Virginia
155 Rugby Road 22904-4119
(434) 924-3592
www.virginia.edu/artmuseum/

Norfolk

Chrysler Museum of Art
245 West Olney Road 23510
(757) 664-6200
www.chrysler.org/index.asp

Richmond

Virginia Museum of Fine Arts
2800 Grove Avenue 23221-2466
(804) 204-2701
www.vmfa.state.va.us/

Roanoke

Art Museum of Western Virginia
Center in the Square
One Market Square 24011-1436
(540) 342-5760
www.artmuseumroanoke.org/

Williamsburg

Muscarelle Museum of Art
College of William and Mary
Jamestown Road 23187-8795
(757) 221-2710
www.wm.edu/muscarelle/

Washington

Goldendale

Maryhill Museum of Art
35 Maryhill Museum Drive 98620
(509) 773-3733
www.maryhillmuseum.org/

Pullman

Washington State University Museum of Art
Wilson Road and Stadium Way 99164-7460
(509) 335-1910
www.wsu.edu/artmuse/

Seattle

Frye Art Museum
704 Terry Avenue 98104
(206) 622-9250
www.fryeart.org/

Seattle Art Museum
100 University Street 98101-2902
(206) 654-3100
www.seattleartmuseum.org/

Burke Museum of Natural History & Culture
University of Washington
17th Avenue NE and NE 45th Street
(206) 543-5590
www.washington.edu/burkemuseum/

Spokane

Jundt Art Museum
Gonzaga University
202 East Cataldo Avenue
(509) 323-3891
www.gonzaga.edu/

Tacoma

Tacoma Art Museum
1123 Pacific Avenue 98402-4399
(253) 272-4258
www.tacomaartmuseum.org/

West Virginia

Huntington

Huntington Museum of Art
2033 McCoy Road 25701
(304) 529-2701
www.hmoa.org/

Sunrise Art Museum
746 Myrtle Road 25314
(304) 344-8035
www.sunrisemuseum.org/

Wisconsin

Beloit

Wright Museum of Art
Beloit College
700 College Street 53511
(205) 254-2566
www.beloit.edu/~museum/wright/

Madison

Elvehjem Art Museum
University of Wisconsin-Madison
800 University Avenue 53706-1479
(608) 263-2246
www.lvm.wisc.edu/

Madison Art Center
211 State Street 53703
(608) 257-0158
www.madisonartcenter.org/

APPENDIX

Wisconsin Academy Gallery
Wisconsin Academy of Sciences,
 Arts and Letters
1922 University Avenue 53726
(608) 263-1692
www.wisconsinacademy.org/gallery/index.html

Wisconsin Union Galleries
University of Wisconsin-Madison
Memorial Union
800 Langdon Street 53706
(608) 265-3000
www.sit.wisc.edu/~wudart/

Milwaukee

Charles Allis Art Museum
1801 North Prospect Avenue 53202
(414) 278-8295
www.cavtmuseums.org/

Haggerty Museum of Art
Marquette University
13th and Clybourn Streets 53201-1881
(414) 288-1669
www.cavtmuseums.org/

Milwaukee Art Museum
700 North Art Museum Drive 53202
(414) 224-3200
www.mam.org

Milwaukee Institute of Art & Design
273 East Erie Street 53202
(414) 276-7889
www.miad.edu/

Oshkosh

Allen Priebe Gallery
University of Wisconsin-Oshkosh
Arts and Communications Building
926 Woodland Avenue 54901
(205) 254-2566
www.uwosh.edu/art/welcome.html

Racine

Racine Art Museum
441 Main Street 53401
(262) 638-8300
www.ramart.org/

Sheboygan

John Michael Kohler Arts Center
608 New York Avenue 53082-0489
(920) 458-6144
www.jmkac.org/

Wausau

Leigh Yawkey Woodson Art Museum
700 North Twelfth Street 54403-5007
(715) 845-7010
www.lywam.org/

Whitewater

Crossman Gallery
University of Wisconsin-Madison
Greenhill Center of the Arts
950 West Main Street
(262) 472-5708
academics.uww.edu/CAC/crossman/

Wyoming

Cheyenne

Wyoming State Museum
Barrett Building
2301 Central Avenue 82002
(307) 777-7022
wyomuseum.state.wy.us/

Jackson Hole

National Museum of Wildlife Art
2820 Rungius Road 83001
(800) 313-9553 (307) 733-5771
www. wildlifeart.org/

Laramie

The University of Wyoming Art Museum
2111 Willett Drive 82071-3807
(307) 766-6622
www.uwyo.edu/artmuseum/index.html

Sundance

Crook County Museum and Art Gallery
309 Cleveland Street 82729-0063
(303) 283-3666
wyshs.org/mus-crookcty.htm

A Selection of Museums Around the World

The Art Gallery of New South Wales
Sydney, Australia
www.artgallery.nsw.gov.au/
This site offers access to the collections of the Sydney's Art Gallery of New South Wales Museum, including Australian, Aboriginal, Asian, western and contemporary art, and photography.

The Art Gallery of Ontario
Ontario, Canada
www.ago.net/navigation/flash/index.cfm
This site offers access to the collections of the the Art Gallery of Ontario, including paintings, sculpture, prints and drawings including European 15th-20th century and British 18th-20th century.

The Ashmolean Museum
Oxford, England
www.ashmol.ox.ac.uk/
This site provides access to the collections of the University of Oxford's Ashmolean Museum. Among the departments are antiquities, the cast gallery, the coin room, Eastern art, and Western art.

The Benaki Museum
Athens, Greece
www.benaki.gr/index-en.htm
Access to the art collections and the photographic and historical archives of the Benaki Museum are featured at this site.

The British Museum
London, England
www.thebritishmuseum.ac.uk/
Among this site's highlights is the opportunity to explore the British Museum's collections, which are organized under these categories: Africa, Americas, Asia, Britain, Egypt, Europe, Greece, Japan, Near East, Pacific, and Rome.

The Egyptian Museum
Cairo, Egypt
www.egyptianmuseum.gov.eg/
This site provides access to the wide variety of objects ranging from the prehistoric era to the Greco-Roman period.

Galleria degli Uffizi
Florence, Italy
www.uffizi.firenze.it/
This site provides access to the collections of the Florence's Uffizi Gallery, with information about its history and its buildings.

Guggenheim Museum
Bilbao, Spain
www.guggenheim-bilbao.es/ingles/home.htm
This site provides access to the collections of the Guggenheim Museum in Bilbao, Spain, with information about its collection, exhibitions, and buildings.

Hong Kong Museum of Art
www.lcsd.gov.hk/CE/Museum/Arts/index.html
This site provides access to the collections, exhibitions, and activities associated with the Hong Kong Museum of Art.

Hunterian
Glasgow, Scotland
www.hunterian.gla.ac.uk/
This site provides access to the collections of the museum and art gallery at the University of Glasgow.

Kunsthistorisches Museum
Vienna, Austria
www.mbam.qc.ca/a-sommaire.html
This site provides access to the collections of Vienna's Kunsthistorisches Museum, with information about its collection, exhibitions, and buildings.

Montreal Museum of Fine Arts
Montreal, Canada
www.mbam.qc.ca/a-sommaire.html
This site provides access to the collections of the Montreal Museum of Fine Arts, featuring Canadian art, Inuit art, and art by European masters.

Musée du Louvre
Paris, France
www.louvre.fr/louvrea.htm
Enjoy a virtual tour of the Louvre Museum in Paris by visiting the museum's 350 rooms with over 1,500 pictures. The site also provides a Paris Virtual Guide, featuring thousands of pictures of the City of Lights.

Musée d'Orsay
Paris, France
www.musee-orsay.fr/
Access to the Musée d'Orsay's collections is available, as well as information about the museum's building.

APPENDIX

Musep Nacional del Prado
Madrid, Spain
museoprado.mcu.es/home.html.
Access to the Prado Museum's collections is available, as well as information about the museum's building as well as current and previous exhibits.

The Museum of Classical Archaeology
Cambridge, England
www.classics.cam.ac.uk/ark.html
The University of Cambridge's Museum of Classical Archaeology is one of the few surviving collections of casts of Greek and Roman sculpture in the world. The public collection of the Museum is made up of over six hundred plaster casts of Greek and Roman sculptures.

The National Gallery
London, England
www.nationalgallery.org.uk/
Access to the entire collection of London's National Gallery of Art is available at this site. Extensive categories assist the search.

National Gallery of Australia
Canberra, Australia
www.nga.gov.au/Home/index.cfm
This site provides access to the collections of the National Gallery of Australia collections of Australian and international art plus information about its exhibitions.

National Gallery of Canada
Ottawa, Canada
musee.beaux-arts.ca/
This site provides access to the collections of the National Gallery of Canada in Ottawa. Among the departments are Canadian art and Inuit art.

The National Gallery of Ireland
Dublin, Ireland
www.nationalgallery.ie/
The National Gallery of Ireland's collection of Irish art and European master paintings is available through this site.

National Galleries of Scotland
Edinburgh, Scotland
www.nationalgalleries.org/
This site provides access to the collections of Scotland's National Gallery, National Portrait Gallery, and National Gallery of Modern Art.

The National Gallery of Wales
Cardiff, Wales
www.nmgw.ac.uk/art/
Information about the collections of the art museum, and its collection of British and European art.

The National Museum of Modern Art
Tokyo, Japan
www.momat.go.jp/english_page/index_e.html
Information about the collections of the art museum, the crafts gallery, and the film center is available at this site.

National Palace Museum
Taipei, Taiwan
www.npm.gov.tw/english/index-e.htm
This site provides access to one of the most extensive collections of Chinese Art at Taiwan's National Palace Museum, featuring ceramics, porcelain, calligraphy, painting, and ritual bronzes.

National Portrait Gallery
London, England
www.npg.org.uk/live/index.asp
Founded in 1856, the National Portrait Gallery in London is the most comprehensive of its kind in the world. The site offers a convenient tool for searching the online database of gallery images.

Rijksmuseum
Amsterdam, Netherlands
rijksmuseum.nl/asp/start.asp?language=uk
Access to the extensive holdings of the Rijksmuseum is available through this site. A highlight is the virtual tour of 150 museum rooms and 1,250 of the museum's most popular exhibits.

Royal Academy
London, England
www.royalacademy.org.uk/
This site provides access to the Royal Academy's collections plus information about its exhibitions.

Royal Museums of Fine Arts of Belgium
Brussels, Belgium
www.fine-arts-museum.be/site/EN/default.asp
This site provides access to the museums, collections, and exhibitions of the Museum of Ancient Art, the Museum of Modern Art, the Wiertz Museum, and the Meunier Museum.

Royal Ontario Museum
Toronto, Canada
www.rom.on.ca/
This site provides access to the galleries, collections, and exhibitions of the Royal Ontario Museum.

Shanghai Art Museum
Shanghai, China
www.echinaart.com/GALLERY/ShanghaiArtMuseum.htm
Among the Shanghai Art Museum's collections are calligraphy, photography, sculpture, ceramics, and watercolors.

The State Hermitage Museum
St. Petersburg, Russia
www.hermitagemuseum.org/html_En/index.html
Situated in the center of St. Petersburg, the State Hermitage Museum is housed in five magnificent buildings created by celebrated architects of the 18th to 19th Centuries. Assembled throughout two and a half centuries, the Hermitage's collections of works of art (over 3,000,000 items) present the development of the world culture and art from the Stone Age to the 20th Century.

Staatliche Museen
Berlin, Germany
www.smb.spk-berlin.de/e/m.html
This site provides information about sixteen national museums located in Berlin.

Tate Collections
London, England
www.tate.org.uk/home/default.htm
This site provides access to the entire collection of Britain's Tate Museums—over 25,000 works of British and international art, each with its own information page.

The Vatican Museums
Rome, Italy
www.vatican.va/phome_en.htm
Through this site, access is available to the Vatican library, museum, and archives. Information about the Vatican as a city-state is also provided. Gaining virtual access to the Vatican's extensive art collection is sufficient reason to visit this site.

The Victoria and Albert Museum
London, England
www.vam.ac.uk/
This site features information about London's Victoria and Albert Museum, with access to it collections, its exhibitions, and its history.

The Whitworth Art Gallery
Manchester, England
www.whitworth.man.ac.uk/
This site features information about the collections, exhibitions, and events at the Whitworth Art Gallery.

APPENDIX

Websites of General Interest

Art History Network
www.arthistory.net/index.html
This site investigates a wide range of resources related to art history, archaeology, and architecture. Entries are arranged by artists, civilizations, and historical eras.

Art History Resources on the Web
witcombe.sbc.edu/ARTHLinks.html
This site offers an extensive listing of art-related resources on the Internet, arranged by period. Also available are links to image finders and online reviews. Especially helpful are links to museums and galleries in over thirty nations around the world.

Art Links on the Web
www.bc.edu/bc_org/avp/cas/fnart/Artweb.html
This site offers an extensive listing of art-related resources on the Internet, arranged in more than 50 categories.

Artchive
www.artchive.com/
This extensive site provides a gallery representing more than 200 artists, art exhibit reviews, online exhibitions, theory and criticism, reviews of commercially available CD-ROM art collections, and links to a variety of related Internet resources.

Artcyclopedia
www.artcyclopedia.com/
This site offers an extensive listing of art-related resources on the Internet, including art museums worldwide and art headlines.

Artlex Art Dictionary
www.artlex.com/
Available at this site is a dictionary with definitions for 3,000+ terms, 1000+ images, and cross-references.

Art-Related Links
www.metmuseum.org/education
 er_online_resourc.asp#related
New York's Metropolitan Museum of Art provides this collection of links to websites grouped by particular periods and styles of art and architecture.

Athena
www.ge-dip.etat-ge.ch/athena/html/athome.html
This site provides thousands of links to Internet resources related to art, literature, and science. Raphael's *School of Athens* receives special attention at this site, which provides information about several of the characters present in the painting.

CGFA-Carol Gerten Fine Arts
cgfa.sunsite.dk/index.html
This extensive site provides a gallery of the works of hundreds of artists, alphabetically arranged.

Catholic Encyclopedia
www.newadvent.org/cathen/
As its name implies, this site intends to provide full and authoritative information on a wide range of Catholic interests, action, and doctrine.

Dictionary of Art Historians
www.lib.duke.edu/lilly/dah.htm
This site provides a database for locating information about the background of major art historians of Western art history.

HyperHistory Online
www.hyperhistory.com/online_n2/
 History_n2/a.html
This site offers 2,000 files covering 3,000 years of world history. Its files are classified by people, history, events, and maps, with sub-categories related to art, music, poetry, religion, theology, culture, philosophy, science, technology, economy, discovery, politics, and war.

Index of Christian Art
ica.princeton.edu/
Access to more than 60,000 images plus an index of more than 20,000 works of art produced from early apostolic times until A.D. 1400 are available at this site.

Internet History Sourcebooks Project
www.fordham.edu/halsall/
Associated with Fordham University, this site provides links to a wide range of Internet resources related to the humanities. The project's main sourcebooks include ancient history, Medieval studies, and modern history. Among its subsidiary sourcebooks are African history, East Asian history, Indian history, Islamic history, Jewish history, and the history of science.

The Labyrinth: Resources for Medieval Study
www.georgetown.edu/labyrinth/
Sponsored by Georgetown University, this site provides valuable resources covering a wide range of topics, including Arthurian studies, national cultures, the Crusades, Medieval women, Vikings, music, religion, science, plus texts in five languages. Other categories include arts and architecture; archaeology and cartography; philosophy and theology; and heraldry, arms, and chivalry.

Mother of All Art History Links Pages
www.art-design.umich.edu/mother/
This site provides links to art history-related web resources—including museums, art history departments, online visual collections, and research resources.

Museums Around the World
vlmp.museophile.sbu.ac.uk/world.html
A listing of museums in more than fifty nations is available at this site.

MyStudios.com
www.mystudios.com/
This site examines famous forgeries, women in art, and the greatest works of art. Information about the specific works of such artists as Manet, Rembrandt, and Vermeer is also provided.

ORB: The Online Reference Book
 for Medieval Studies
orb.rhodes.edu/
Sponsored by Rhodes College, the ORB provides an encyclopedia, a library of online primary texts, a reference shelf of online sources, resources for teaching, and links to related Internet resources.

The Perseus Digital Library
www.perseus.tufts.edu/
Supported by Tufts University, this elaborate site offers information about a broad range of topics related to the Western world. The Perseus collection contains a wide variety of resources, including primary and secondary texts, site plans, digital images, and maps. Art and archaeology catalogs document a wide range of objects—over 1,500 vases, over 1,800 sculptures and sculptural groups, over 1,200 coins, hundreds of buildings from nearly 100 sites, and over 100 gems. Catalog entries are linked to tens of thousands of images, many in high resolution, and have been produced in collaboration with many museums, institutions, and scholars.

Thais Club
www.thais.it/default_uk.htm
This versatile site offers links to a wide range of topics, including 40 centuries of architecture, 1200 years of sculpture, Italian cities, botany, and entomology.

Treasures of the World: Stories Behind
 Masterworks of Art and Nature
www.pbs.org/treasuresoftheworld/index.html
Sponsored by PBS, this site offers insights about the theft of Leonardo's *Mona Lisa* early in the 20th Century; the Faberge Eggs commissioned by the Czars of Russia; *Guernica*, Picasso's reminder of war; the legend of the notorious Hope Diamond; the creation of the Taj Mahal; and the re-discovery of Borobudur.

Visual Art Resources from the
 Internet Public Library
www.ipl.org/div/subject/browse/hum20.80.00/
This site provides an extensive list of websites related to drawing, painting, sculpture, and photography.

Voice of the Shuttle
vos.ucsb.edu/
Sponsored by the University of California at Santa Barbara, this site provides links to a wide range of Internet resources. Among its categories are archaeology, architecture, art, art history, literature, philosophy, and religion.

Web Gallery of Art
www.kfki.hu/~arthp/welcome.html
The Web Gallery of Art contains over 8,000 digital reproductions of European paintings and sculptures created between the years 1150 and 1750. The site features biographies of many of the artists, and many of the pieces of art are accompanied by commentary.

World Art Treasures
www.bergerfoundation.ch/
Sponsored by the Jacques-Eduoard Berger Foundation, this site features collections of slides, essays, and audio recordings—all related to well-known artists and their works.

The WWW Virtual Library
vlib.org/Overview.html
This extensive site provides links to a wide range of Internet resources related to more than a dozen disciplines. Among its categories are archaeology, architecture, art, geography, linguistics, literature, performing arts, and philosophy.

APPENDIX

Art-Related Web Resources

The Andy Warhol Homepage
www.warhol.dk/
This site provides a biography of Andy Warhol, a gallery, and links to several related Internet resources.

The Appreciation of Chinese Calligraphy
www.chinapage.org/calligraphy.html
This site examines samples of the work of Tu Meng of the Tang dynasty (618-905), who developed 120 expressions to describe different styles of calligraphy and established criteria for them.

The Cave of Lascaux
www.culture.fr/culture/arcnat/lascaux/en/
This site provides information about the 1940 discovery of the world's best-known prehistoric cave drawings. A map of the cave allows for a virtual tour of several of the cave's most famous rooms and paintings. A flashlight is provided.

The Chauvet-Pont-d'Arc Cave
www.culture.fr/culture/arcnat/chauvet/en/
gvpda-d.htm
Discovered in 1994, this cave and its prehistoric drawings rival those of Lascaux. This site provides an account of the cave's discovery, a collection of the cave's bestiary, a map of the cave, and information about the scientific investigation.

The Christian Catacombs of Rome
www.catacombe.roma.it/index.html
This site, sponsored by the Instituo Salesiano S. Callisto in Rome, provides a wide array of photographs and extensive information about the Catacombs of St. Callixtus, the spirituality of the catacombs, and the Christians of the persecutions.

Eloquent Elegance: Beadwork in the Zulu Cultural Tradition
minotaur.marques.co.za/clients/zulu/
This site provides information about the significance of traditional Zulu beadwork and its relation to the Zulu social values.

Exploring the Sistine Chapel Ceiling
www.science.wayne.edu/~mcogan/Humanities/
Sistine/index.html
Explore the layout of the ceiling with a photographic map of the entire ceiling and compare the state of the ceiling before and after its cleaning. Also explore the panels of the ceiling panels.

Georgia O'Keeffe Museum
www.okeeffemuseum.org/indexflash.php
Information about Sante Fe, New Mexico's Georgia O'Keeffe Museum is provided at this site, which includes samples from the permanent collection.

Guide to Hopi Kachinas
www.hopiart.com/kach-exp.htm
This site provides information about Hopi Kachinas and their roles in Hopi life and religion.

In Aedibus Aldi: The Legacy of Aldus Manutius and His Press
www.lib.byu.edu/~aldine/aldus.html
An extensive examination of the influence of Aldus Manutius is found at this site. From the Aldine Press came Greek and Latin classical texts, grammars, religious writings, contemporary secular writings, popular works, political and scientific writings, history, and geography.

Leonardo da Vinci
www.museoscienza.org/english/leonardo/
Default.htm
Sponsored by the National Museum of Science and Technology in Milan, Italy, this site examines a wide range of topics related to Leonardo. In addition to a gallery and a biography, the site offers links to exhibits that feature Leonardo's manuscripts and machines. The Virtual Leonardo link enables site visitors to make a walking or flying tour of rooms and cloisters; operate a number of Leonardo machines; see other visitors, follow their movements and chat with them; and join a group and be shown around by a guide.

Leonardo da Vinci: Scientist, Inventor, Artist
www.mos.org/leonardo/
Sponsored by Boston's Museum of Science, this site offers a virtual tour of a traveling exhibition that the museum hosted in 1997. In addition to providing an extensive biographical account, the site also addresses the following topics: Inventor's Workshop, Leonardo's Perspective, and Leonardo: Right to Left.

Michelangelo
hometown.aol.com/dtrofatter/michel.htm
This site provides extensive biographical information about Michelangelo, with links to works of art and related Internet sites.

Michelangelo

www.michelangelo.com/buon/bio-index2.html

This site provides detailed information about Michelangelo's life, with the presentation divided into three headings: early life, mid years, and final days.

Musée Marmottan Monet

www.marmottan.com/uk/sommaire/

This site offers biographical information about Claude Monet and a virtual museum that includes approximately 170 of his works.

Musée Rodin

www.musee-rodin.fr/welcome.htm

In addition to a biography about Auguste Rodin, this site for the Musée Rodin in Paris offers an extensive collection of images accompanied by commentary.

On-Line Picasso Project

www.tamu.edu/mocl/picasso/

In addition to a biography about Pablo Picasso, this site offers an extensive collection of images and links to Picasso collections at museums around the world.

Renoir

www.expo-renoir.com/

This site offers biographical information about Pierre-Auguste and a virtual museum that includes approximately 200 of his works.

The Rodin Museum

www.rodinmuseum.org/

Sponsored by the Philadelphia Museum of Art, this site provides an account of the conservation of the Philadelphia version of Rodin's *The Thinker*, which suffered from the effects of pollution after having been displayed outside for more than sixty years.

Salvador Dalí Museum

www.salvadordalimuseum.org/

This site provides an exhibit of many Dalí works plus biographical information.

The Vincent van Gogh Gallery

www.vangoghgallery.com/

In addition to providing a thorough biography, this site claims that it displays 100% of Vincent van Gogh's works and letters. Also addressed is the controversy related to van Gogh fakes.

The Warhol

www.warhol.org/

This site provides information about Pittsburgh's Andy Warhol Museum, whose permanent collection is comprised of more than 4,000 works of art by Warhol, including paintings, drawings, prints, photographs, sculpture, film, and videotapes. The museum's archive includes records, source material for works of art, and other documents of the artist's life.

APPENDIX

Architecture-Related Web Resources

Chateau de Versailles
www.chateauversailles.fr/EN/
A virtual tour of the Chateau de Versailles is available at this site, which features a map of the grounds, a biography the Sun King, and a collection of art.

China's Forbidden City
www.chinavista.com/beijing/gugong/!start.html
This site provides a virtual tour of the seat of Imperial power during the Ming and Qing dynasties.

Explore the Taj Mahal
www.taj-mahal.net/topEng/index.htm
This site provides a virtual tour of the Taj Mahal, with 360-degree panoramas, movies, maps, and narration.

The Giza Plateau Mapping Project (GPMP)
www-oi.uchicago.edu/OI/PROJ/GIZ/Giza.html
This site investigates the construction and function of the Sphinx and the Great Pyramids.

Great Wall of China
www.walkthewall.com/greatwall/
A virtual tour of the Great Wall of China is available at this intriguing site, which focuses on a section of the wall between Jinshanling and Simatai.

Images of Medieval Art and Architecture
www.pitt.edu/~medart/
This site provides access several architectural wonders in Europe—including those at St. Denis, Chartres, and Amiens..

Mysterious Places
www.mysteriousplaces.com/index.html
This site provides examines sacred sites and ancient civilizations around the world, including Chichén Itzá, Easter Island, Mali, Mesa Verde, and Stonehenge.

Mystery of the Maya
www.civilization.ca/civil/maya/mminteng.html
In support of the IMAX film, *Mystery of the Maya*, this site examines the Maya civilization, including the Maya calendar, writing, hieroglyphics, mathematics, astronomy, cosmology, and religion.

The Pompeii Forum Project
jefferson.village.virginia.edu/pompeii/
This site offers an extensive archive of photographs that chronicle excavations among the ruins of ancient Pompeii.

Pyramids: The Inside Story
www.pbs.org/wgbh/nova/pyramid/
Sponsored by the PBS, this site is intended to accompany the NOVA broadcast that investigated recent excavations at the Great Pyramids and the Sphinx at Giza.

Ravenna—World Heritage Site
www.turismo.ravenna.it/eng/
This site provides virtual tours of the Mausoleum of Galla Placidia, the Basilica of San Vitale, and the Arian Baptistry.

Roman Art and Architecture
harpy.uccs.edu/roman/
This site examines the architecture, painting, and sculpture of ancient Rome and its influence. Specific attention is devoted to Rome, Pompeii, and Athens. To facilitate searching, topics are arranged by historical period.

The Seven Wonders of the Ancient World
ce.eng.usf.edu/pharos/wonders/index.html
This site features artists' renderings of the Seven Wonders of the Ancient World: the Great Pyramid of Giza, the Hanging Gardens of Babylon, the Statue of Zeus at Olympia, the Temple of Artemis at Ephesus, the Mausoleum at Halicarnassus, the Colossus of Rhodes, and the Lighthouse of Alexandria.

The Stone Pages
www.stonepages.com/
Detailed information ad virtual tours of European megaliths and other ancient sites—including stone circles, dolmens, standing stones, cairns, barrows, and hillforts—are available at this site.

Theban Mapping Project
www.thebanmappingproject.com/
This site provides information about the archaeological investigation in the area surrounding Thebes, on the west bank of the Nile near Luxor, Egypt. Included in the research is the Valley of the Kings and KV5.

Ancient Cultures on the Web

The Anasazi Heritage Center
www.co.blm.gov/ahc/hmepge.htm
This site includes information about the Anasazi, who built the cliff dwellings in the Southwest U.S. between A.D. 450 and 1300.

Archaeology of Teotihuacan, Mexico
archaeology.la.asu.edu/teo/
This site provides an informative introduction, a map, and recent excavation reports about Teotihuacan, an ancient capital of the Aztec Empire.

Egypt: A New Look @ an Ancient Culture
www.upenn.edu/museum/Exhibits/egyptintro.html
This site investigates the customary topics: hieroglyphs, pharaohs, pyramids, and deities.

Egyptology Resources
www.newton.cam.ac.uk/egypt/
Established with the assistance of the Newton Institute in the University of Cambridge, this site provides a wide variety of Egyptological information.

Guardian's Egypt
guardians.net/egypt/
This site provides an extensive investigation of ancient Egypt, including an examination of the pyramids, mummies, hieroglyphs, and deities. Also included is specific attention to King Tutankhamun; the Great Sphinx at Giza; and links to related Internet resources.

Harappa
www/harappa.com/welcome.html
This site provides images, artwork, and historical information about Harappa and its civilization that flourished in the Indus Valley around 2,500 B.C. Also included is a virtual tour of the city of Harappa.

In the Footsteps of Alexander the Great
www.mpt.org/programsinterests/mpt/alexander/
This companion site to the PBS documentary follows the journey of Alexander and his army as they swept across Asia.

Islamic Art and Architecture
www.islamicart.com/
This site provides extensive information about Islamic architecture, calligraphy, rugs, and coins, plus links to museums with noteworthy Islamic art exhibits around the world.

LacusCurtius: Into the Roman World
www.ukans.edu/history/index/europe/
 ancient_rome/E/Roman/home.html
This site lists links to resources related to Roman antiquity, including these categories: archaeology; history; religion; and art and literature.

Mysteries of Egypt
www.civilization.ca/civil/egypt/
 egypt_e.html
In support of the IMAX film, *Mysteries of Egypt*, this site examines the ancient Egyptian civilization, with background information about the Nile Valley, mummification, and Tutankhamun.

Secrets of Easter Island
www.pbs.org/wgbh/nova/easter/
Sponsored by the Public Broadcasting System, this site seeks to unravel a central mystery of Easter Island: how hundreds of giant stone statues that dominate the island's coast were moved and erected.

The Shrine of the Goddess Athena
www.goddess-athena.org
This site provides extensive information about the patroness of Athens, including a museum with countless exhibits, an atlas, a timeline, and numerous links to related Internet resources.

Transformation of English Letters to Hieroglyphic
www.tourism.egnet.net/Cafe/
 TOR_TRN.asp
A tool at this site will convert any English word to a hieroglyphics representation.

Visit Mummies of Ancient Egypt
www.si.umich.edu/CHICO/mummy
This site provides information about the mummification process, plus a key to hieroglyphs, a timeline, and a glossary.

Wonders of the African World
www.pbs.org/wonders/
Sponsored by PBS, this site examines African history throughout the world. Topics include the Black Kingdoms of the Nile, the Swahili Coast, the Slave Kingdoms, the Holy Land, the Road to Timbuktu, and the Lost Cities of the South.

Glossary

Abacus — The slab that forms the upper part of a capital.

Academy — Derived from Akademeia, the name of the garden where Plato taught his students; the term came to be applied to official (generally conservative) teaching establishments.

acrylic — A clear plastic used to make paints and as a casting material in sculpture.

aesthetic — Describes the pleasure derived from a work of art, as opposed to any practical or informative value it might have. In philosophy, aesthetics is the study of the nature of art and its relation to human experience.

agora — In ancient Greek cities, the open marketplace, often used for public meetings.

aisle — In church architecture, the long open spaces parallel to the nave.

allegory — A dramatic or artistic device in which the superficial sense is accompanied by a deeper or more profound meaning.

altar — In ancient religion, a table at which offerings were made or victims sacrificed. In Christian churches, a raised structure at which the sacrament of the Eucharist is consecrated, forming the center of the ritual.

Altarpiece — A painted or sculptured panel placed above and behind an altar to inspire religious devotion.

ambulatory — Covered walkway around the apse of a church.

amphora — Greek wine jar.

anthropomorphism — The endowing of nonhuman objects or forces with human characteristics.

apse — Eastern end of a church, generally semicircular, in which the altar is housed.

architecture — The art and science of designing and constructing buildings for human use.

architrave — The lowest division of an entablature.

archivault — The molding that frames an arch.

assemblage — The making of a sculpture or other three-dimensional art piece from a variety of materials. Compare collage, montage.

atelier — A workshop.

atrium — An open court in a Roman house or in front of a church.

autocracy — Political rule by one person of unlimited power.

avant-garde — French for advance-guard. Term used to describe artists using innovative or experimental techniques.

axis — An imaginary line around which the elements of a painting, sculpture or building are organized; the direction and focus of these elements establishes the axis.

Bronze Age — The period during which bronze (an alloy of copper and tin) was the chief material for tools and weapons. It began in Europe around 3000 B.C. and ended around 1000 B.C. with the introduction of iron.

barrel vault — A semicircular vault unbroken by ribs or groins.

bas-relief — Low relief; see relief.

basilica — Originally a large hall used in Roman times for public meetings, law courts, etc.; later applied to a specific type of early Christian church.

black figure — A technique used in Greek vase painting which involved painting figures in black paint in silhouette and incising details with a sharp point. It was used throughout the Archaic period. Compare red figure.

burin — Steel tool used to make copper engravings.

buttress — An exterior architectural support.

Corinthian — An order of architecture that was popular in Rome, marked by elaborately decorated capitals bearing acanthus leaves. Compare Doric, Ionic.

caliph — An Arabic term for leader or ruler.

calligraphy — The art of penmanship and lettering.

campanile — In Italy the bell tower of a church, often standing next to but separate from the church building.

canon — From the Greek meaning a "rule" or "standard." In architecture it is a standard of proportion. In religious terms it represents the authentic books in the Bible or the authoritative prayer of the Eucharist in the Mass or the authoritative law of the church promulgated by ecclesiastical authority.

capital — The head, or crowning part, of a column, taking the weight of the entablature.

capitulary — A collection of rules or regulations sent out by a legislative body.

cartoon — (1) A full-scale preparatory drawing for a picture, generally a large one such as a wall painting. (2) A humorous drawing.

caryatid — A sculptured female figure taking the place of a column.

cast — A molded replica made by a process whereby plaster, wax, clay, or metal is poured in liquid form into a mold. When the material has hardened the mold is removed, leaving a replica of the original from which the mold was taken.

catharsis — Literally, "purgation." Technical term used by Aristotle to describe the emotional effect of a tragic drama upon the spectator.

cathedra — The bishop's throne. From that word comes the word cathedral, i.e., a church where a bishop officiates.

cella — Inner shrine of a Greek or Roman temple.

ceramics — Objects made of baked clay, such as vases and other forms of pottery, tiles, and small sculptures.

chancel — The part of a church that is east of the nave and includes choir and sanctuary.

chapel — A small space within a church or a secular building such as a palace or castle, containing an altar consecrated for ritual use.

chevet — The eastern (altar) end of a church.

chiaroscuro — In painting, the use of strong contrasts between light and dark.

choir — The part of a church chancel between nave and sanctuary where the monks sing the Office; a group of singers.

classical — Generally applied to the civilizations of Greece and Rome; more specifically to Greek art and culture in the 5th and 4th centuries B.C. Later imitations of classical styles are called neoclassical. Classical is also often used as a broad definition of excellence: a "classic" can date to any period.

clerestory — A row of windows in a wall above an adjoining roof.

cloister — The enclosed garden of a monastery, surrounded by a covered walkway; by extension the monastery itself. Also, a covered walkway alone.

codex — A manuscript volume.

coffer — In architecture, a recessed panel in a ceiling.

collage — A composition produced by pasting together disparate objects such as train tickets, newspaper clippings, or textiles. Compare assemblage, montage.

colonnade — A row of columns.

composition — Generally, the arrangement or organization of the elements that make up a work of art.

concetto — Italian for "concept." In Renaissance and Baroque art, the idea that undergirds an artistic ensemble.

consul — One of two Roman officials elected annually to serve as the highest state magistrates in the Republic.

contrapposto — In sculpture, placing a human figure so that one part (e.g., the shoulder) is turned in a direction opposite to another part (e.g., the hip and leg).

cornice — The upper part of an entablature.

cruciform — Arranged or shaped like a cross.

crypt — A vaulted chamber, completely or partially underground, which usually contains a chapel. It is found in a church under the choir.

cult — A system of religious belief and its followers.

cuneiform — A system of writing, common in the ancient Near East, using characters made up of wedge shapes. Compare hieroglyphics.

Doric — One of the Greek orders of architecture, simple and austere in style. Compare Corinthian, Ionic.

daguerreotype — Early system of photography in which the image is produced on a silver-coated plate.

design — The overall conception or scheme of a work of art. In the visual arts, the organization of a work's composition based on the arrangement of lines or contrast between light and dark.

dialectics — A logical process of arriving at the truth by putting in juxtaposition contrary propositions; a term often used in medieval philosophy and theology, and also in the writings of Hegel and Marx.

dome — A hemispherical vault.

Epicurean — A follower of the Greek philosopher Epicurus, who held that pleasure was the chief aim in life.

echinus — The lower part of the capital.

elevation — In architecture, a drawing of the side of a building which does not show perspective.

encaustic — A painting technique using molten wax colored by pigments.

engraving — (1) The art of producing a depressed design on a wood or metal block by cutting it in with a tool. (2) The impression or image made from such a wood or metal block by ink that fills the design. Compare burin, etching, woodcut.

entablature — The part of a Greek or Roman temple above the columns, normally consisting of architrave, frieze, and cornice.

entasis — The characteristic swelling of a Greek column at a point about a third above its base.

epithet — Adjective used to describe the special characteristics of a person or object.

etching — (1) The art of producing a depressed design on a metal plate by cutting lines through a wax coating and then applying corrosive acid that removes the metal under the lines. (2) The impression or image made from such a plate by ink that fills the design. Compare engraving, woodcut.

evangelist — One of the authors of the four Gospels in the Bible: Matthew, Mark, Luke, and John.

facade — The front of a building.

ferroconcrete — A modern building material consisting of concrete and steel reinforcing rods or mesh.

flute — Architectural term for the vertical grooves on Greek (and later) columns generally.

foreshortening — The artistic technique whereby a sense of depth and three-dimensionality is obtained by the use of receding lines.

form — The arrangement of the general structure of a work of art.

fresco — A painting technique that employs the use of pigments on wet plaster.

frieze — The middle section of an entablature. A band of painted or carved decoration, often found running around the outside of a Greek or Roman temple.

Gesamtkunstwerk — German for "complete work of art." The term, coined by Wagner, refers to an artistic ensemble in which elements from literature, music, art, and the dance are combined into a single artistic totality.

Greek cross — A cross with arms of equal length.

gallery — A long, narrow room or corridor, such as the spaces above the aisles of a church.

genre — A type or category of art. In the visual arts, the depiction of scenes from everyday life.

glaze — In oil painting a transparent layer of paint laid over a dried painted canvas. In ceramics a thin coating of clay fused to the piece by firing in a kiln.

gospels — The four biblical accounts of the life of Jesus, ascribed to Matthew, Mark, Luke, and John. Compare evangelist.

gouache — An opaque watercolor medium.

graphic — Description and demonstration by visual means.

ground — A coating applied to a surface to prepare it for painting.

guilloche — A decorative band made up of interlocking lines of design.

hadith — Islamic law/traditions outside of the Qu'ran.

haj — The Islamic pilgrimage to Mecca.

hamartia — Literally Greek for "missing the mark," "failure," or "error." Term used by Aristotle to describe the character flaw that would cause the tragic end of an otherwise noble hero.

happening — In art, a multimedia event performed with audience participation so as to create a single artistic expression.

hedonism — The philosophical theory that material pleasure is the principal good in life.

hegira — Muhammad's flight from Mecca to Medina; marks the beginning of the Islamic religion.

hierarchy — A system of ordering people or things which places them in higher and lower ranks.

hieroglyphics — A system of writing in which the characters consist of realistic or stylized pictures of actual objects, animals, or human beings (whole or part). The Egyptian hieroglyphic script is the best known, but by no means the only one. Compare cuneiform.

hippodrome — A race course for horses and chariots. Compare spina.

hubris — The Greek word for "insolence" or "excessive pride."

humanist — In the Renaissance, someone trained in the humane letters of the ancient classics and employed to use those skills. More generally, one who studies the humanities as opposed to the sciences.

Ionic — One of the Greek orders of architecture, elaborate and grace-ful in style. Compare Doric, Corinthian.

Iron Age — The period beginning in Europe around 1000 B.C. during which iron was the chief material used for tools and weapons.

icon — Greek word for "image." Panel paintings used in the Orthodox church as representations of divine realities.

iconography — The set of symbols and allusions that gives meaning to a complex work of art.

ideal — The depiction of people, objects, and scenes according to an idealized, preconceived model.

idol — An image of a deity that serves as the object of worship.

image — The representation of a human or nonhuman subject, or of an event.

impasto — Paint laid on in thick textures.

incising — Cutting into a surface with a sharp instrument.

intercolumniation — The horizontal distance between the central points of adjacent columns in a Greek or Roman temple.

jamb — Upright piece of a window or a door frame, often decorated in medieval churches.

keystone — Central stone of an arch.

kore — Type of standing female statue produced in Greece in the Archaic period.

kouros — Type of standing male statue, generally nude, produced in Greece in the Archaic period.

Latin cross — A cross with the vertical arm longer than the horizontal arm.

lancet — A pointed window frame of a medieval Gothic cathedral.

landscape — In the visual arts, the depiction of scenery in nature.

lekythos — Small Greek vase for oil or perfume, often used during funeral ceremonies.

line engraving — A type of engraving in which the image is made by scored lines of varying width.

lintel — The piece that spans two upright posts.

lithography — A method of producing a print from a slab of stone on which an image has been drawn with a grease crayon or waxy liquid.

liturgy — The rites used in public and official religious worship.

loggia — A gallery open on one or more sides, often with arches.

lunette — Semicircular space in wall for window or decoration.

lyre — Small stringed instrument used in Greek and Roman music. Compare cithara.

lyric — (1) Words or verses written to be set to music. (2) Description of a work of art that is poetic, personal, even ecstatic in spirit.

Madonna — Italian for "My Lady." Used for the Virgin Mary.

Mass — The most sacred rite of the Catholic liturgy.

mandorla — Almond-shaped light area surrounding a sacred personage in a work of art.

matroneum — Gallery for women in churches, especially churches in the Byzantine tradition.

mausoleum — Burial chapel or shrine.

meander — Decorative pattern in the form of a maze, commonly found in Greek Geometric art.

metopes — Square slabs often decorated with sculpture which alternated with triglyphs to form the frieze of a Doric temple.

michrab — A recessed space or wall design in a mosque to indicate direction of Mecca for Islamic worshippers.

mobile — A sculpture so constructed that its parts move either by mechanical or natural means.

monastery — A place where monks live in communal style for spiritual purposes.

monochrome — A single color, or variations on a single color.

montage — (1) In the cinema, the art of conveying an idea and/or mood by the rapid juxtaposition of different images and camera angles. (2) In art, the kind of work made from pictures or parts of pictures already produced and now forming a new composition. Compare assemblage, collage.

mosaic — Floor or wall decoration consisting of small pieces of stone, ceramic, shell, or glass set into plaster or cement.

mosque — Islamic house of worship.

mullions — The lines dividing windows into separate units.

mural — Wall painting or mosaics attached to a wall.

myth — Story or legend whose origin is unknown; myths often help to explain a cultural tradition or cast light on a historical event.

Neanderthal — Early stage in the development of the human species, lasting from before 100,000 B.C. to around 35,000 B.C.

Neolithic — Last part of the Stone Age, when agricultural skills had been developed but stone was still the principal material for tools and weapons. It began in the Near East around 8000 B.C. and in Europe around 6000 B.C.

narthex — The porch or vestibule of a church.

nave — From the Latin meaning "ship." The central space of a church.

niche — A hollow recess or indentation in a wall to hold a statue or other object.

obelisk — A rectangular shaft of stone that tapers to a pyramidal point.

oculus — A circular eye-like window or opening.

oil painting — Painting in a medium made up of powdered colors bound together with oil, generally linseed.

order — (1) In classical architecture a specific form of column and entablature; see Doric, Ionic, and Corinthian. (2) More generally, the arrangement imposed on the various elements in a work of art.

orientalizing — Term used to describe Greek art of the 7th century B.C. that was influenced by Eastern artistic styles.

Paleolithic — The Old Stone Age, during which human beings appeared and manufactured tools for the first time. It began around two and a half million years ago.

palette — (1) The tray on which a painter mixes colors. (2) The range and combination of colors typical of a particular painter.

panel — A rigid, flat support, generally square or rectangular, for a painting; the most common material is wood.

pantheon — The collected gods. By extension, a temple to them. In modern usage a public building containing the tombs or memorials of famous people.

pantocrator — From the Greek meaning "one who rules or dominates all." Used for those figures of God and/or Christ found in the apses of Byzantine churches.

parable — A story told to point up a philosophical or religious truth.

pastel — A drawing made by rubbing colored chalks on paper.

pathos — That aspect of a work of art that evokes sympathy or pity.

pediment — The triangular space formed by the roof cornices on a Greek or Roman temple.

pendentives — Triangular architectural devices used to support a dome of a structure; the dome may rest directly on the pendentives. Compare squinches.

peripatetic — Greek for "walking around." Specifically applied to followers of the philosopher Aristotle.

peristyle — An arcade (usually of columns) around the outside of a building. The term is often used of temple architecture.

perspective — A technique in the visual arts for producing on a flat or shallow surface the effect of three dimensions and deep space.

piazza — Italian term for a large, open public square.

pieta — An image of the Virgin with the dead Christ.

pietra serena — Italian for "serene stone." A characteristic building stone often used in Italy.

pilaster — In architecture a pillar in relief.

plan — An architectural drawing showing in two dimensions the arrangement of space in a building.

podium — A base, platform, or pedestal for a building, statue, or monument.

polis — The Greek word for "city," used to designate the independent city-states of ancient Greece.

polychrome — Several colors. Compare monochrome.

portal — A door, usually of a church or cathedral.

portico — A porch with a roof supported by columns.

pre-socratic — Collective term for all Greek philosophers before the time of Socrates.

prophet — From the Greek meaning "one who speaks for another." In the Hebrew and Christian tradition it is one who speaks with the authority of God. In a secondary meaning, it is one who speaks about the future with authority.

proportion — The relation of one part to another, and each part to the whole, in respect of size, whether of height, width, length, or depth.

prototype — An original model or form on which later works are based.

psalter — Another name for the Book of Psalms from the Bible.

Qur'an — The sacred scriptures of Islam.

realism — A 19th-century style in the visual arts in which people, objects, and events were depicted in a manner that aimed to be true to life. In film, the style of Neorealism developed in the post-World War II period according to similar principles.

red figure — A technique used in Greek vase painting which involved painting red figures on a black background and adding details with a brush. Compare black figure.

relief — Sculptural technique where- by figures are carved out of a block of stone, part of which is left to form a background. Depending on the degree to which the figures project, the relief is described as either high or low.

reliquary — A small casket or shrine in which sacred relics are kept.

requiem — A Mass for the dead.

revelation — Divine self-disclosure to humans.

sanctuary — In religion, a sacred place. The part of a church where the altar is placed.

sarcophagus — From the Greek meaning "flesh eater." A stone (usually limestone) coffin.

satire — An amusing exposure of folly and vice, which aims to produce moral reform.

satyr — Greek mythological figure usually shown with an animal's ears and tail.

scale — More generally, the relative or proportional size of an object or image.

scriptorium — That room in a medieval monastery in which manuscripts were copied and illuminated.

section — An architectural drawing showing the side of a building.

secular — Not sacred; relating to the worldly.

silhouette — The definition of a form by its outline.

spandrel — A triangular space above a window in a barrel vault ceiling, or the space between two arches in an arcade.

spina — A monument at the center of a stadium or hippodrome, usually in the form of a triangular obelisk.

squinches — Either columns or lintels used in corners of a room to carry the weight of a superimposed mass. Their use resembles that of pendentives.

stele — Upright stone slab decorated with relief carvings, frequently used as a grave marker.

still life — A painting of objects such as fruit, flowers, dishes, etc., arranged to form a pleasing composition.

stoa — A roofed colonnade, generally found in ancient Greek open markets, to provide space for shops and shelter.

stoic — School of Greek philosophy, later popular at Rome, which taught that the universe is governed by Reason and that Virtue is the only good in life.

stretcher — A wooden or metal frame on which a painter's canvas is stretched.

stylobate — The upper step on which the columns of a Greek temple stand.

summa — The summation of a body of learning, particularly in the fields of philosophy and theology.

sura — A chapter division in the Qur'an, the scripture of Islam.

syllogism — A form of argumentation in which a conclusion is drawn from a major premise by the use of a minor premise: all men are mortal/Socrates is a man/ therefore Socrates is mortal.

symmetry — An arrangement in which various elements are so arranged as to parallel one another on either side of an axis.

tabernacle — A container for a sacred object; a receptacle on the altar of a Catholic church to contain the Eucharist.

tambour — The drum that supports the cupola of a church.

tempera — A painting technique using coloring mixed with egg yolk, glue, or casein.

terra cotta — Italian meaning "baked earth." Baked clay used for ceramics. Also sometimes refers to the reddish-brown color of baked clay.

tesserae — The small pieces of colored stone used for the creation of a mosaic.

tholos — Term in Greek architecture for a round building.

toga — Flowing woolen garment worn by Roman citizens.

tragedy — A serious drama in which the principal character is often brought to disaster by his/her hamartia, or tragic flaw.

transept — In a cruciform church, the entire part set at right angles to the nave.

triglyphs — Rectangular slabs divided by two vertical grooves into three vertical bands; these alternated with metopes to form the frieze of a Doric temple.

triptych — A painting consisting of three panels. A painting with two panels is called a diptych; one with several panels is a polyptych.

trompe l'oeil — From the French meaning "to fool the eye." A painting technique by which the viewer seems to see real subjects or objects instead of their artistic representation.

trumeau — A supporting pillar for a church portal, common in medieval churches.

tympanum — The space, usually decorated, above a portal, between a lintel and an arch.

value — The property of a color that makes it seem light or dark.

vanishing point — In perspective, the point at which receding lines seem to converge and vanish.

vault — A roof composed of arches of masonry or cement construction.

volutes — Spirals that form an Ionic capital.

votive — An offering made to a deity either in support of a request or in gratitude for the fulfillment of an earlier prayer.

voussoirs — Wedge-shaped blocks in an arch.

woodcut — (1) A wood block with a raised design produced by gouging out unwanted areas. (2) The impression or image made from such a block by inking the raised surfaces. Compare engraving, etching, lithograph.

ziggurat — An Assyrian or Babylonian stepped pyramid.